Digital Infrared Photography

Professional Techniques and Images

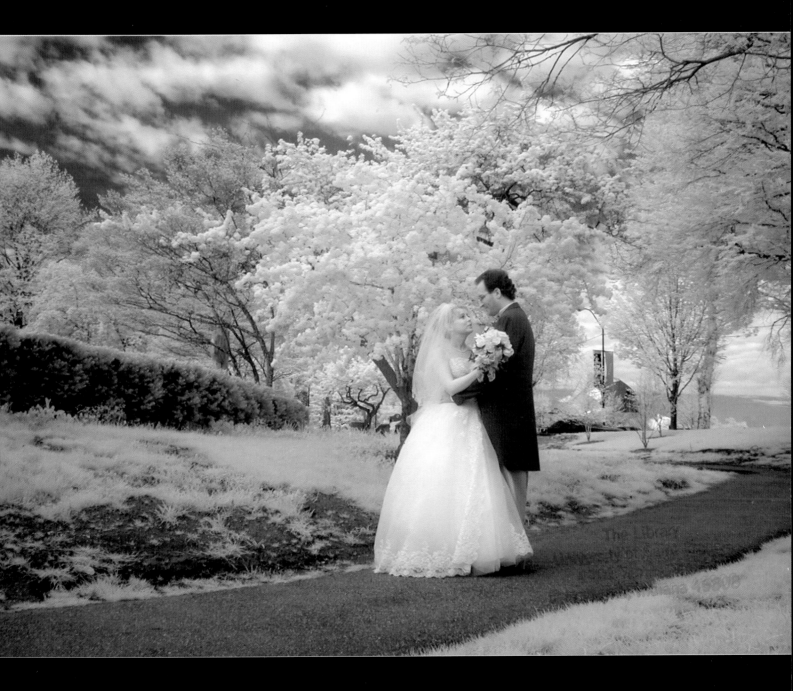

AMHERST MEDIA, INC. ■ BUFFALO, NY

Copyright © 2005 by Patrick Rice.
Photo on page 1 by Jacob Jakuszeit.
All rights reserved.

Published by:
Amherst Media®
P.O. Box 586
Buffalo, N.Y. 14226
Fax: 716-874-4508
www.AmherstMediax.com

Publisher: Craig Alesse
Senior Editor/Production Manager: Michelle Grant
Assistant Editor: Barbara A. Lynch-Johnt

ISBN: 1-58428-144-8
Library of Congress Control Number: 2004101346

Printed in Korea.
10 9 8 7 6 5 4 3 2 1

Notice of Disclaimer: The information contained in this book is based on the author's experience and opinions. The author and publisher will not be held liable for the use or misuse of the information in this book.

CONTENTS

Photograph by Patrick Rice.

Photograph by Patrick Rice.

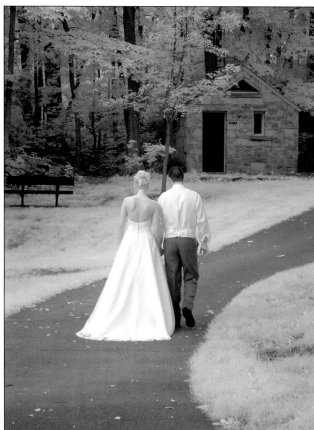

Photograph by Patrick Rice.

ABOUT THE AUTHOR

Patrick Rice (M.Photog.Cr., CPP, PFA ALPA, Hon-ALPA) of North Olmsted, Ohio, has been a professional photographer for more than twenty-six years. He holds a Bachelor of Science degree from Cleveland State University, the Professional Photographers of America (PPA) Master of Photography and Photographic Craftsman degrees, as well as all five levels of the Wedding and Portrait Photographers International (WPPI) Masters degree. He holds the designation of Certified Professional Photographer from the PPA and the Professional Photographers of Ohio (PPO) and has received the Advanced Medallion Award from the Ohio Certified Professional Photographers Commission. He is also the recipient of the Fellowship Award from the Photographic Art Specialists of Ohio (PASO) and Service Award Medallion from the Society of Northern Ohio Professional Photographers (SONOPP). Patrick has received countless Best of Show honors and has also been included in the PPA Loan Collection and PPO's Ohio Top Ten. He

has been named Photographer of the Year by SONOPP five times and twice by the Akron Society of

Professional Photographers (ASPP). In 1997, Patrick was WPPI's Grand Award Winner in the portrait cate-

Photograph by Barbara Rice.

gory, and one of his wedding images received a perfect score of 100 at the Award of Excellence Print Competition. He has accumulated seven Court of Honor Awards in the wedding category at the Mid-East States Regional Print Competition, and in 2001, he received two Fuji Masterpiece Awards, a score of 99 on one of his wedding images, and was named the Ohio Photographer of the Year by the PPO. In addition, he has won the Wedding Award Trophy twice from the Triangle Photographers Association.

Patrick Rice has been actively involved in photographic associations for many years. He is a past president of the PPO, SONOPP, ASPP, and PASO. He also serves as a PPA councilor from Ohio and has served on the PPA Standards Committee and the Wedding Group. He has been presented the President's Award from both the PPO and the ASPP and has received the Madison Geddes Award for outstanding contributions to SONOPP. In 2000, Patrick received the Honorary Accolade of Lifetime Photographic Excellence from WPPI. In addition, he was selected to receive the Photography Leadership Award from the International Photographic Council at the United Nations in New York City.

Patrick has lectured and judged extensively throughout the United States and Canada. He has presented programs at both the PPA and WPPI annual conventions. His work has been published in several photographic magazines, and he has authored the following books: *Infrared Wedding Photography, The Professional Photographer's Guide to Success in Print Competition,* and *Professional Digital Imaging for Wedding and Portrait Photographers,* all from Amherst Media.

CONTRIBUTORS

Michael Ayers—The recipient of two Master of Photography degrees and the United Nations Leadership award, Michael has made a career of giving back to the photographic industry. He has invented album designs and and construction concepts, authored countless articles and books, and has lectured to more than 25,000 photographers worldwide. To view samples of Michael's work, visit his website at www.TheAyers.com.

Barbara J. Ellison—Barbara has worked as a promarket representative with Canon for the past fifteen years. As an artist, she specializes in pastel hand-colored photographs and infrared. She has taught flower imaging at Palm Beach Photographic Workshops and also helps her husband with his orchid business in Goldvein, Virginia.

Don Emmerich, M.Photog., M.Artist, M.EI, Cr., CEI, CPPS—Don is one of only six living photographers to earn all four professional photographic degrees and teaches over a dozen digital imaging seminars a year.

For more than twenty-two years, Don has practiced photography as both an art and a science. He has also distinguished himself by his dedication to bringing the benefits of digital imaging into the mainstream of professional photography.

Don has traveled to over two dozen countries on four continents as a teacher, lecturer, and the technical editor of *Professional Photographer* magazine. He continues to monitor and evaluate ongoing developments in the digital imaging sciences, sharing his wisdom with countless eager professionals everywhere.

Fallon Miller—Fallon is an associate photographer and administrative assistant at Rice Photography Inc. She received her formal training in photography from the Ohio Institute of Photography and Technology where she received an Associate of Applied Science degree in 2003. Her expertise is in the areas of digital imaging and Photoshop. She is an active member of the Triangle Professional Photographers Association.

Gary Fong—Gary's path to a career in professional photography was highly unexpected. With a degree in pharmacology, Gary worked in hospitals, labs, emergency rooms, and pathology departments and anticipated a career as a physician. All of that changed when he decided—for richer or poorer—to begin a career in wedding photography simply because, "I wanted to be around happier people."

Today, Gary is an internationally renowned photographer who completes photographic assignments world-wide and lectures around the globe. His work has been profiled in numerous international magazines and books, his images have appeared on numerous magazine covers and in national ad campaigns, and he was recently featured in the Ed Pierce's monthly video magazine, *Photo Vision*. He was also featured as one of the world's top-ten photographers in Weddings 2000, a televised satellite broadcast, which opened at over ninety United Artists theaters

and was attended by more than 10,000 photographers throughout the United States. Weddings 2000 was the largest educational event ever held in the history of professional photography.

One of the first professional photographers to convert to 100 percent digital, Gary has a history of being a leader in the fields of computer imaging, software development, and design. He is the creator of the industry-standard Montage software (now marketed by Art Leather Mfg. Co, the world's largest manufacturer of albums and folios), which is the most successful software package ever created for professional photographers. In 2001, he founded Pictage, Inc.'s Digital Professional Lab, which quickly became the country's largest professional digital lab and reached profitability within fourteen months. In 2004, Pictage merged forces with the Internet's top wedding and registry website, WeddingChannel.com.

Richard Frumkin—Richard has been taking photos for most of his life. At a very early age, Rick began recording the people and places he encountered. His professional photographic career began over thirty years ago while he was in college. He was a staff photographer at the University of Cincinnati where he worked on the school newspaper and magazines. At the University, his study of photography helped him to secure assignments as a photojournalist with the *Cincinnati Enquirer*.

Upon returning to Cleveland, Rick worked for several of the leading wedding photography studios before joining Rice Photography. Rick has worked closely with both Patrick and Barbara Rice to hone his skills and develop a style consistent with the studio.

Rick has won several awards for his images over the years, and his work has been displayed at many local photography and art shows.

Travis Hill, PPA Cert., AHPA, CPP, M.Photog.Cr.—Travis holds PPA's Master of Photography and Photographic Craftsman degrees and was one of the association's youngest recipients of these high honors. He also holds the Accolade of Lifetime Photographic Achievement from WPPI. He has earned the degree of Certified Professional Photographer from both PPA and PPO. In addition to having one of his images accepted in the PPA Traveling Loan Collection, he has collected four Court of Honor Awards for his wedding photography. Travis has lectured extensively with his parents on wedding and infrared photography. He was a speaker at the PPA Annual Convention in 1999 and WPPI in 2003 and has lectured to audiences both large and small across the country. His images have been selected for inclusion in the PPA Loan Book, PPA Gallery Book, and the WPPI Annual editions. Travis is coauthor of *Infrared Wedding Photography* (Amherst Media 2000).

Jacob Jakuszeit—Jacob has been in love with photography for many years. This passion for imaging led him to Rice Photography, where he has worked as a wedding photographer for the past five years. Having photographed his first wedding solo at age sixteen, Jacob has always stepped up and excelled. Graduating at the top of his class from North Olmsted High School, Jacob is also an Eagle Scout. Jacob went on to study photography at Baldwin Wallace College, and his photographs have earned him awards in numerous photographic competitions. His grasp of digital imaging and photojournalistic style make him an excellent image-maker.

Robert Knuff—Robert is a professional photographer with over forty years' experience in the industry. He holds the Master of Photography and Photographic Craftsman degrees from PPA. He has served on the board of trustees of the Professional Photographers of Ohio and as the president of the Triangle Professional Photographers Association.

Michelle Perkins—Michelle is a professional writer and digital photo retoucher specializing in wedding, portrait, and architectural imaging. She has written for *PC Photo* and *Rangefinder* and is the author of *Traditional Photographic Effects with Adobe® Photoshop®* (2nd ed., 2004), *Beginner's Guide to Adobe® Photoshop®* (2nd ed., 2004), and *Color Correction and Enhancement with Adobe® Photoshop®* (2004), and three forthcoming titles—*Beginner's Guide to Adobe® Photoshop®*

Elements®, The Practical Guide to Digital Imaging, and *Digital Landscape Photography Step by Step.* (All of these books are available from Amherst Media.)

Barbara Rice, PPA Cert., AHPA, M.Photog.Cr., CPP—Barbara has had an extensive professional photography career that has allowed her to work for studios in four states in the past twenty-six years. She received her formal photographic education from the Rhode Island School of Photography and has gone on to earn numerous professional degrees, including PPA's Master of Photography and Photographic Craftsman Degrees. In addition, she holds the Accolade of Lifetime Photographic Excellence and Honorary Accolade of Lifetime Photographic Excellence Degrees from WPPI. Barbara has received numerous awards in WPPI print competitions and had the highest-scoring print in the entire 1998 WPPI Award of Excellence Competition—a score of 99! Her creative wedding albums have received the Fuji Masterpiece Award, and one was accepted into the PPA Loan Collection. Barbara is a co-author of *Infrared Wedding Photography* (Amherst Media 2000).

Don Spangler—Don is a professional photographer with over seventeen years of experience. He has been very involved in professional photography associations, serving all of the positions of the Professional Photographers of Southwest Ohio including a term as its president. He has created several merit prints in competitions for PPA, as his work has been widely recognized for its craftsmanship and artistry. Don's technical knowl-edge of the craft of photography has been the catalyst to some of his most outstanding images throughout the years.

Chad Tsoufiou—Chad is one of the brightest young stars in the field of wedding photography. With over ten years' experience taking pictures, his talents have matured quickly. His formal training in photography began at Lake High School in Hartsville, Ohio. From there, Chad went on to study photography at Kent State University. He excelled at Kent, being named to the Dean's List four times and graduated with a degree in photo illustration. He has won many awards for his photography through the years and has worked as a portrait and commercial photographer. Working both as the primary and secondary (documentary) photographer at Rice Photography, Chad has developed a unique ability to capture the emotions of the wedding day.

James Williams—James is a professional photographer from Champion, Ohio with over twenty years' experience. He has earned the designation of Certified Professional Photographer from both PPA and PPO. In addition, James is the recipient of the Accolade of Photographic Mastery degree from WPPI. He is active in several photographic associations and has served as president of SONOPP.

James Wooten—James Wooten is a photography enthusiast and lab instructor at Mississippi State University. His interest in infrared imaging led him to experiment with internal filter removal in digital cameras. His writings paved the way for digital camera modifications across the country.

Tony Zimcosky—A native of Cleveland, Ohio, Tony is committed to recording the true feelings and emotions of each bride and groom he photographs. What started as a hobby over twenty-six years ago has now become his passion. Whether he is choosing the perfect location for a romantic image or posing the bridal party to make everyone look their best, Tony's concern for excellence and his enthusiasm for creating the high-quality photos is evident. His photos have won numerousawards in photographic competitions, and he is very close to completing all of the requirements for WPPI's Accolade of Photographic Mastery degree.

Monte Zucker—Monte is a world-famous photographer who has received every award the industry offers. The United Nations recently honored him as Portrait Photographer of the Year 2002. He has also received WPPI's Lifetime Achievement Award. He feels that his most special honor, however, is the fact that his popularity with photographers of all ages is continually growing.

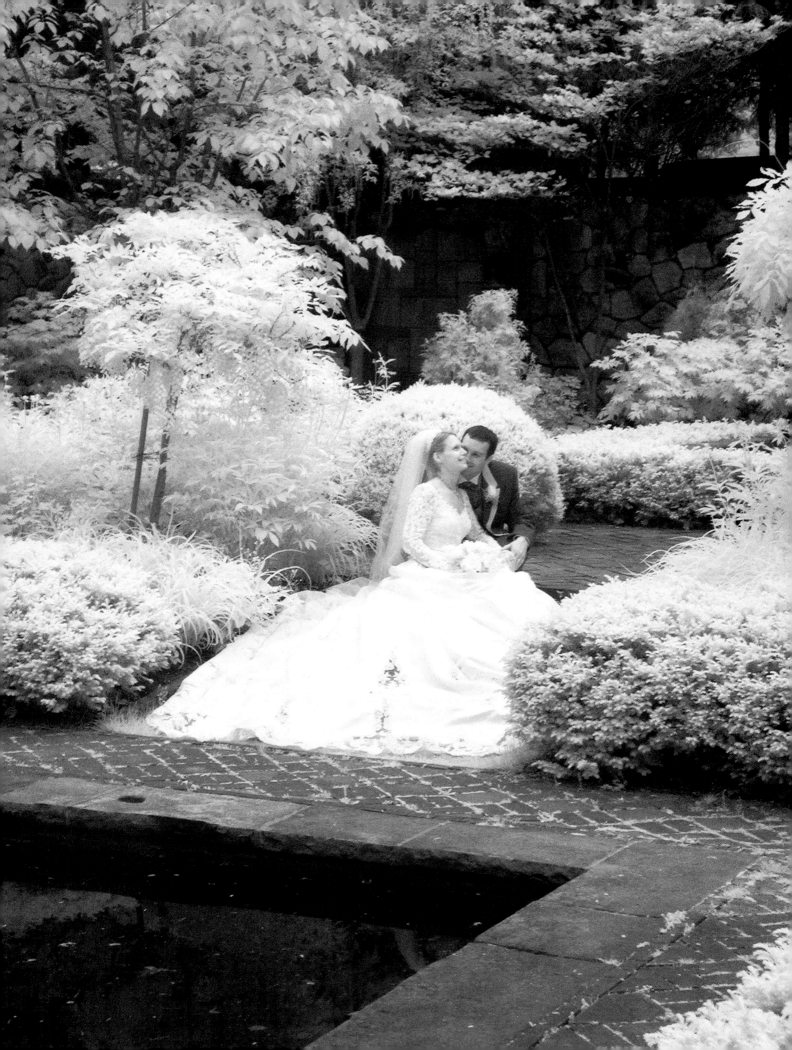

INTRODUCTION

Infrared photography has long been one of the most interesting and mysterious applications of photography. From infrared's earliest beginnings in the 1920s and 1930s with technical and scientific films to its current applications in landscape as well as portrait and wedding photography, infrared has fascinated photographers. As an artist, I appreciate infrared photography for its ethereal qualities. The businessman in me appreciates the competitive advantage that using infrared imaging provides for my studio.

If you have never experimented with infrared imaging, there is no time like the present. If infrared imaging is something that you did back in photography school but haven't used lately, it is time to rediscover this interesting media. If you are a veteran infrared film user who is looking to move into the digital age, then this book will help you through the transition.

▶ **INFRARED PHOTOGRAPHY HAS LONG BEEN ONE OF THE MOST INTERESTING AND MYSTERIOUS APPLICATIONS OF PHOTOGRAPHY.**

Digital infrared photography for me was a natural extension from shooting infrared film for so many years. When we decided to make the transition to digital capture for our portrait and wedding work, we looked for a digital solution for creating infrared imaging.

The purpose of this book is to show photographers that infrared image capture can be done with digital cameras and techniques as well as it could be with traditional infrared films. I hope that you get as much reward from viewing these images and reading this text as I and others have had in creating them.

Infrared photography has long had its uses in scientific applications. Today, it's one of the best-loved styles of portraiture for clients who desire a unique image. Photograph by Tony Zimcosky.

THE HISTORY OF INFRARED PHOTOGRAPHY

William Herschel. Scientist William Herschel is credited with discovering infrared in part because he described the relationship and similarity between heat and light. Herschel determined that there were

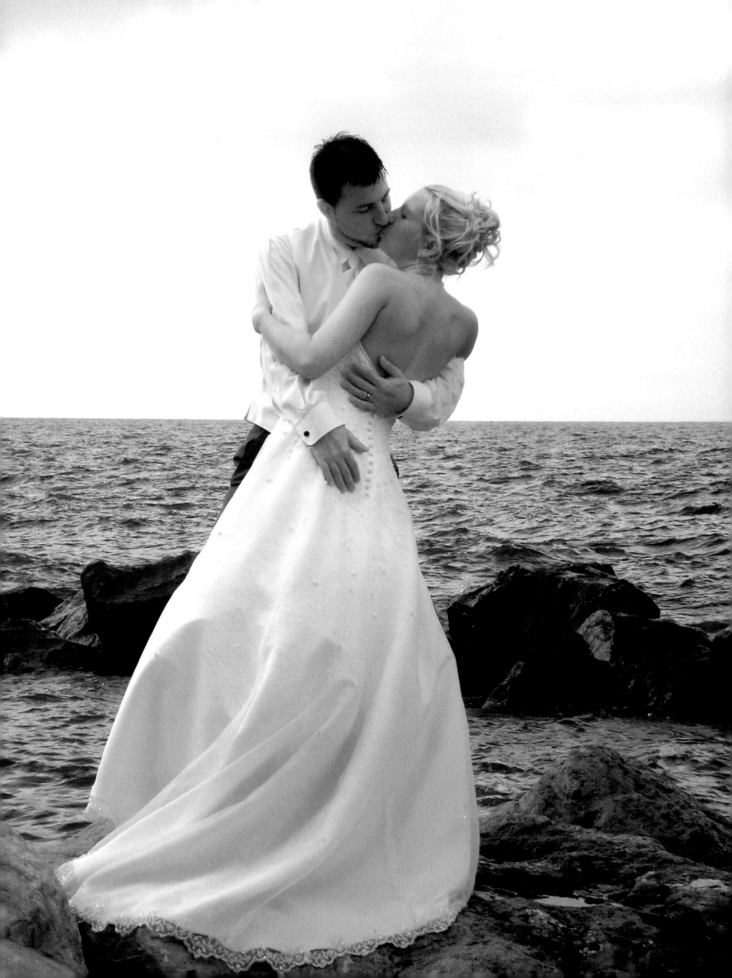

light rays emitted from the sun that were not visible, yet they existed and could even produce heat. Although William Herschel was essentially only an amateur astronomer, his discoveries and technical achievements were of enormous significance. William Herschel was responsible for increasing the recognized dimensions of the Milky Way, discovering the satellites of Saturn and the rotation of Saturn's rings, as well as the motion of binary stars. Herschel experimented extensively with techniques for grinding and polishing specula. When Herschel made his remarkable discovery of Uranus in 1781, his fame quickly spread, and King George III (who was himself interested in in astronomy and a patron of the leading astronomers) was duly impressed. This led to a royal appointment and a grant of £200 a year to pursue his inquiries first at the king's seat, Datchet, near Windsor, and later at Slough. In return he was expected to show the royal family and their guests interesting astronomical observations. The king even rewarded Herschel with £4,000 toward the construction of what was then the world's largest telescope, which was a reflector, 40 feet in length with a massive 48-inch mirror.

It was through his observations of the sun that Herschel accidentally discovered the existence of infrared radiation. Using thermometers and prisms he made experiments that led to a series of papers being published in 1800 on the discovery of the independent behavior of radiant heat and infrared light.

▶ IT WAS THROUGH HIS OBSERVATIONS OF THE SUN THAT HERSCHEL ACCIDENTALLY DISCOVERED THE EXISTENCE OF INFRARED RADIATION.

Walter Clark. Walter Clark is considered the father of infrared photography. Clark, who was involved in the development of infrared film in 1920s and 1930s at the Eastman Kodak Company, first published an article on the use of infrared photography in the *Journal of the Biological Photographic Association* in 1934. He described some of the earliest photography with infrared—landscapes taken in 1924 by the U.S. Army. He also reviewed the sensitization of emulsions for infrared then discussed cameras, lenses, and filtration.

He briefly mentioned other applications in medicine, forensic science, and paleontology noting, for instance, that breast cancer could be detected through proper illumination, and theorizing that infrared photography could enhance the results. He repeated these findings in "Photography of the Infrared" in 1937 (*Am. Ann. of Photography* 15: 13–22) and also wrote a chapter entitled "Photography by Ultraviolet and Infrared," which appeared in K. Henney and B. Dudley's *Handbook of Photography* (McGraw-Hill, 1939). His definitive work on infrared radiation, *Photography by Infrared* (Chapman and Hall), was published in 1939.

In his published work, Clark described infrared photographs of the face, noting that African American skin appeared to reflect infrared radiation and that Clark noted that in infrared, Caucasian skin appeared chalky, red lips recorded light, and that some lines of the face were exaggerated. This discovery, needless to say, would later prove quite important to professional photographers.

H. Lou Gibson. H. Lou Gibson, another forefather of today's infrared photography was, for many years, editor and consultant in medical, biological, scientific, and technical photography for the Eastman Kodak Company. He was a contributing member and a fellow of the Biological Photographic Association (BPA), as well as a registered biological photographer of the BPA in the medicine specialty. In 1964 he won the BPA's Communications Award for original work in infrared color photography and medicine. In 1945, Gibson wrote a research paper on the infrared photography of patients with particular medical conditions ("Infrared Photography of Patients," *Medical Radiography and Photography*: 21, no. 3: 72–86). A true pioneer in the field, Gibson described the use of flash equipment, the need to test camera equipment for infrared leakage, the requirement for even, wraparound lighting, and the technique of unsharp area masking for accentuating fine detail. The paper also explained how infrared photography could be used in the detection of breast cancer. In 1978, Gibson updated Walter Clark's *Photography by Infrared* (3rd. ed., J. Wiley & Sons). Although it is now out of print, this book is considered by many to be the bible of infrared photography.

▶ **IN 1945, GIBSON WROTE A RESEARCH PAPER ON THE INFRARED PHOTOGRAPHY OF PATIENTS WITH PARTICULAR MEDICAL CONDITIONS.**

Modern Masters. In more recent years, several photographers have stepped up to lead a new generation of photographers in their explorations into the world of infrared photography. Laurie White Hayball is the author of both the *Infrared Photography Handbook* (Amherst Media 1995) and its companion, *Advanced Infrared Photography Handbook* (Amherst Media 2001). The text in both of her books is grounded in solid technical information on every aspect of infrared photography. She is considered one of the most talented instructors in the field of infrared. Her books have long been seen as the standard for instruction on infrared in the modern age.

Joseph Paduano is another of today's infrared masters. His popular book *The Art of Infrared Photography* (4th ed., Amherst Media 1998) is well written and beautifully illustrated. Once you view Paduano's images, you'll see that he has a keen understanding of the beauty that infrared imaging can lend to any subject.

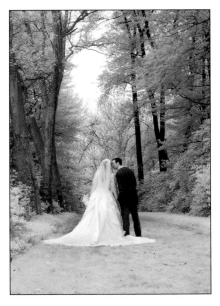

Infrared imaging is a favorite of today's wedding clients. Photograph by Tony Zimcosky.

Another of today's infrared masters is Steven Begleiter, who creates striking images with Kodak color infrared slide film. In his book, *The Art of Color Infrared* (Amherst Media 2002), Steven illustrates the beauty that false-color infrared imaging offers.

Last are the new pioneers in the field of infrared wedding photography. There are several photographers in recent years who have helped to make infrared photography of weddings much more accepted. Ferdinand Neubauer, Richard Beitzal, Gary Fong, Ken Sklute, Don Emmerich, Laurie Klein, and others have contributed greatly through their images, magazine articles, and books. Of course, I consider my family to be important pioneers in this area as well. My wife, Barbara Rice, my stepson Travis Hill, and I published the only book dedicated strictly to this topic. Our book, *Infrared Wedding Photography* (Amherst Media 2000), has been critically acclaimed and is accepted as the definitive guide to this area of infrared photography. Through the years, the three of us have lectured to tens of thousands of photographers on how infrared wedding photography can benefit their photography businesses. My recent articles in the area of digital infrared photography in *Rangefinder, Lens, The Contact Sheet*, and other photographic publications led to the writing of this text.

TECHNICAL APPLICATIONS

As noted earlier, infrared photography began in the scientific, medical, and military applications. Both Walter Clark and H. Lou Gibson of the Eastman Kodak Company found medical applications of infrared film that helped in the detection of certain diseases. Their research papers and books helped doctors the world over in diagnosing common ailments in the human body. Each of these men used both black & white and color infrared films to identify particular health problems.

▶ **AS NOTED EARLIER, INFRARED PHOTOGRAPHY BEGAN IN THE SCIENTIFIC, MEDICAL, AND MILITARY APPLICATIONS.**

Medicine. Medical photography has three purposes: record keeping, illustration, and discovery. In essence, infrared photography can emit luminescence in the infrared range when the subject is illuminated with natural light and can show the transmission of infrared radiation when the subject is illuminated with studio lighting that excites the infrared radiation. Infrared radiation can penetrate 2–3mm into the skin.

In 1967, the Eastman Kodak Company published the first book to deal directly with this subject—*Medical Infrared Photography*. The scientists at Kodak described in great detail numerous examples of how Kodak infrared emulsions could be used in the medical field. One of the major advantages to infrared photography in diagnostics was in

tone differentiation. The veins in a person's skin are more visible with infrared films than normal panchromatic or color films. These tonal differences allow the early and noninvasive discovery of circulation disorders in some patients. Infrared photography is also used in studies of the eye, especially the retina, to emphasize melanotic lesions.

The Military. The military applications have always been one of the most significant uses for infrared films and video. Most of us vividly remember watching the images captured by infrared cameras of the United States' "smart bombs" as the ordnances sought and destroyed their targets. (Again, Walter Clark was instrumental in working with the U.S. Army Air Corp as early as the 1920s with military applications of infrared sensitized recording materials.)

Through my research I found an old magazine advertisement from the Eastman Kodak Company exalting Kodak's role in helping with the war effort in World War II. The ad contains three photographs: One is an image of a factory taken with normal black & white film. The second photograph shows the same area, but the building has been camouflaged so that it can-

▶ **THESE TONAL DIFFERENCES ALLOW THE EARLY AND NONINVASIVE DISCOVERY OF CIRCULATION DISORDERS IN SOME PATIENTS.**

not be detected by aerial surveillance. The third photograph illustrates how Kodak infrared film can detect the false cover or camouflage in an aerial photograph. The ad states, "Natural grass and foliage contain chlorophyll—Nature's coloring matter. Camouflage materials lack this living substance. Chlorophyll reflects invisible infrared light rays—and Kodak infrared film registers this invisible light, making the natural areas look light in the picture—almost white. In violent contrast, the 'dead' camouflaged areas show up dark—almost black—in the picture."

While lecturing in Cincinnati, Ohio some years back on the topic of infrared, I shared this ad with the photographers in attendance. An elderly photographer, George Mayhew, raised his hand to make a comment. George informed all of us that he actually was one of the Army Air Corp photographers in World War II who flew over Nazi Germany looking for munitions plants and army barracks. He regularly used infrared film for camouflage detection as cited in the old magazine ad. He stated very bluntly, "After we got the film developed, we knew where to go back and drop the bombs." This poignant yet chilling statement reinforced infrared film's importance to the war effort at the time.

Recently, I was having a discussion with retired U.S. Coast Guard photographer Jim Perkins. He described how the military used both black & white and color infrared films. Perkins pointed out how dif-

The military applications have historically been one of the most significant uses for infrared films and video.

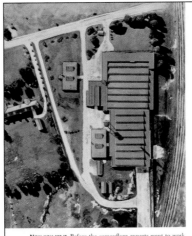

NOW YOU SEE IT. Before the camouflage experts went to work, this factory—a model, for test purposes—was photographed from the air on conventional panchromatic film. The bomber's eye would see what you see—a perfect set-up for destruction.

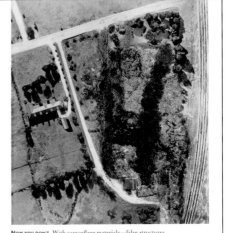

NOW YOU DON'T. With camouflage materials—false structures, netting, cloth streamers, paint, and artificial trees—the experts have fooled the camera, and the bombardier. To the aerial camera loaded with panchromatic film, even the marks of erosion on the slope by the railroad track have disappeared.

Kodak Infrared Film spots the "make believe" of enemy camouflage

Camouflage is the highly developed art of pulling the wool over an enemy's eyes . . . an art which is finding old methods ineffectual, in this war.

This is in a measure due to Kodak's development of a type of film whose vision goes far beyond that of the human eye.

Natural grass and foliage contain chlorophyll—Nature's coloring matter. Camouflage materials lack this living substance. Chlorophyll reflects invisible infrared light rays—and Kodak Infrared Film registers this invisible light, making the natural areas look light in the picture—almost white. In violent contrast, the "dead" camouflaged areas show up dark—almost black—in the picture.

Moreover, Infrared Film is able to penetrate through the haze of a "low-visibility" day, and return from a reconnaissance flight with pictures in clear detail. Here again it far exceeds the power of the human eye.

• • •

Working with our Army and Navy flyers and technicians, Kodak has carried this new technique of camouflage detection to high efficiency—and has, for our own use, helped develop camouflage which defies detection . . . Eastman Kodak Company, Rochester, N. Y.

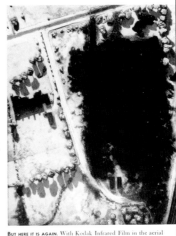

BUT HERE IT IS AGAIN. With Kodak Infrared Film in the aerial cameras, pictures like this are brought back from an observation flight. On Infrared pictures, the false, "dead" camouflage materials look almost black. The natural landscape is unnaturally light. A trained cameraman, with one look, knows where the bombs should strike.

Serving human progress through Photography

89

ferent vegetation would record differently—especially with color infrared slide film. Different plant species would be rendered different shades of red with color infrared. He explained how this would be beneficial in the detection of marijuana plants that were planted in cornfields to hide detection from the air. He would take color infrared images of these innocent-

▶ **DIFFERENT PLANT SPECIES WOULD BE RENDERED DIFFERENT SHADES OF RED WITH COLOR INFRARED.**

looking cornfields in order to detect the growers of these illegal drugs. I never imagined that infrared film was used in the war on drugs!

In 2000, the total United States market for infrared imaging rose to over $1.8 billion with an annual growth rate of more than 6 percent. Military spending accounts for over 90 percent of that total. Security

and surveillance companies are the next largest users of infrared technology. The latest development in infrared imaging is face recognition technology. With security being so important as global terrorism increases, infrared imaging can be used to detect disguises or other means of shielding a person's identity.

I recently spoke with a gentlemen who had just completed five years' service in the U.S. Marine Corp, and he also emphasized the importance of infrared. He was thoroughly trained in the use of infrared imaging—especially infrared night vision equipment. Curiously, he explained that the military has developed clothing that cannot be detected by infrared. He pointed out that all digital images are made up of tiny squares that represent colors. This specially designed clothing is made up of similar tiny squares—thus making it invisible even to infrared night-vision scopes. Our troops can move about at night without being seen by this type of detection device while enemy soldiers cannot. I remarked that you could still see someone's face and hands with infrared spotting scopes, but was told that the military has clothing and masks that cover the soldier from head to toe.

Astronomy. Infrared radiation has also become very important in the field of astronomy. Ironically, almost 300 years after William Herschel first discovered infrared radiation in his study of the stars, infrared radiation is revolutionizing how astronomers look at the heavens. In fact, almost every

▶ **INFRARED PHOTOGRAPHY CAN DETECT PROBLEMS WITH VEGETATION CAUSED BY DISEASE, LACK OF WATER, OR INSECT INFESTATION.**

celestial body has been found to radiate much more strongly in the infrared wavelengths than in any other—and some are only being detected through infrared. In David Allen's book, *Infrared: The New Astronomy* (J. Wiley & Sons 1975) he outlined the many unusual and unexpected astrological discoveries made through infrared research.

Botany and Ecology. Infrared radiation is also used in the observation of plant life and ecology. Infrared photography can detect problems with vegetation caused by disease, lack of water, or insect infestation. Infrared photography's role in the detection of these problems lies in the fact that plants lose their ability to reflect infrared light when they are under stress from one of the aforementioned problems. The farming community relies on infrared imaging for crop studies to detect diseases at an early stage before too much damage has occurred.

The observation of animal populations in the wild is sometimes difficult because of the species' protective coloring that camouflages them and makes them difficult to spot. Many species tend to blend into their surroundings. This coloration does not extend into the

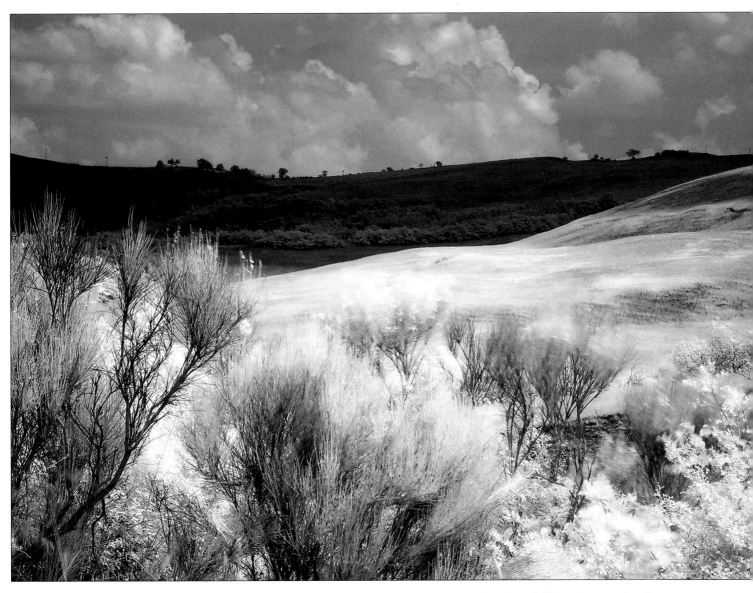

Scientists use infrared imaging to observe plant life and ecology. Photograph by Barbara J. Ellison.

infrared range, and infrared photography can differentiate animals from the vegetation that they live in. This is of great value in tracking the numbers of some animals and determining if a breed is thriving or facing extinction.

Law Enforcement. Infrared photography has been used for many years by law enforcement. Criminal labs employ infrared imaging to expose document forgery or forged paintings and works of art. Even documents that have been badly charred by fire can sometimes be salvaged through infrared imaging.

These technical applications of infrared photography and measurement of infrared radiation in general have, from the beginning, led to developments that have greatly helped portrait photographers. Their breakthroughs have led to improvements in film, equipment, and application for all of us infrared enthusiasts.

Chapter 1

LIGHT

No study of infrared photography would be complete without first understanding what light is and how it works. What we commonly call light is actually energy radiated from the sun in our solar system or some other luminous source. The scientific community refers to this energy from the sun as the electromagnetic spectrum. All energy, from X-rays to radio waves, is part of this spectrum.

WAVELENGTHS

The electromagnetic spectrum is comprised of waves, each of which falls into one of three categories or ranges—ultraviolet, visible, or infrared. The distance between two such waves is deemed its wavelength. By considering the measurement of a particular wavelength (in nanometers—or one-millionth of a meter), we can determine its color and whether the light falls into the ultraviolet, visible, or infrared range.

VISIBLE AND INVISIBLE LIGHT

In our daily lives, we are aware of the wavelengths that comprise the visible spectrum (400–700nm) since the human eye primarily sees in this range. This spectrum is subdivided into colors (red, orange, yellow, green, blue, and violet). Shorter wavelengths are in the blue range, starting at around 400nm. Longer wavelengths in the visible spectrum are in the deep-red range, around 700nm. It is important to note that what we perceive as daylight or white light is actually a mixture of all of the wavelengths of light within this range. This "mix" produces our perception of white.

▶ **BOTH INFRARED FILM AND DIGITAL INFRARED CAMERAS ARE BETTER ABLE TO "PROCESS" LIGHT THAN HUMANS.**

Both infrared film and digital infrared cameras are better able to "process" light than humans. In fact, an infrared camera (or a film

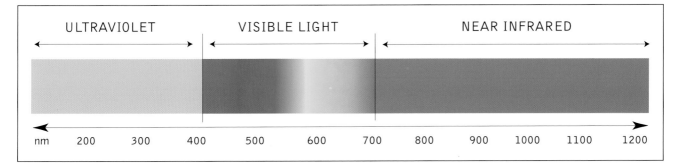

| ULTRAVIOLET | VISIBLE LIGHT | NEAR INFRARED |

| nm | 200 | 300 | 400 | 500 | 600 | 700 | 800 | 900 | 1000 | 1100 | 1200 |

The spectral-range diagram illustrates the breakdown of the wavelenths into distinct categories.

camera equipped with infrared film) can record light from the ultraviolet spectrum (the range of very short waves of light just before the visible spectrum; this will not be dealt with in this book), the visible spectrum, *and* the infrared spectrum.

Because we're interested in recording images made with infrared light, we'll need to block wavelengths from the ultraviolet and visible range from being recorded by the camera. Only once this "light pollution" is diminished or removed can the otherworldly infrared image emerge. Filters play an important role in achieving this goal. We'll delve into their use in detail in chapter 5.

NEAR AND FAR INFRARED

The infrared portion of the electromagnetic spectrum is broken into two distinct categories: near infrared (700–1200nm) and far infrared (beyond 1200nm). The light that is recorded by film and digital cameras is called near infrared, and we can neither see it nor feels its presence. Far infrared, on the

▶ **THE LIGHT THAT IS RECORDED BY DIGITAL AND FILM CAMERAS IS CALLED NEAR INFRARED, AND WE CAN NEITHER SEE IT NOR FEELS ITS PRESENCE.**

other hand, produces heat, which is detected by vision scopes and other equipment reliant on electronic thermography; it is not detectable by the cameras used by professional photographers.

SOURCES OF INFRARED LIGHT

Continuous light sources—such as the sun, tungsten light, and candles, emit both visible light and infrared radiation. Fluorescent or neon lights (discontinuous light sources) supply visible light and may not contain infrared wavelengths. Therefore, with proper filtration, infrared photographs can be made in sunlight and by any continuous artificial light source.

REFLECTANCE VS. ABSORPTION

The infrared radiation that is emitted from or reflected by the subject and other elements of the scene is recorded in infrared photography. The strength of the infrared wavelengths being reflected varies from

subject to subject. The time of day, season, temperature, and even the sun's position while you are creating the photograph will also affect your results. While learning about how infrared sees will help (you'll find information on this topic in chapter 8), the ability to see your image on your camera's LCD monitor is your best ally in creating strong images.

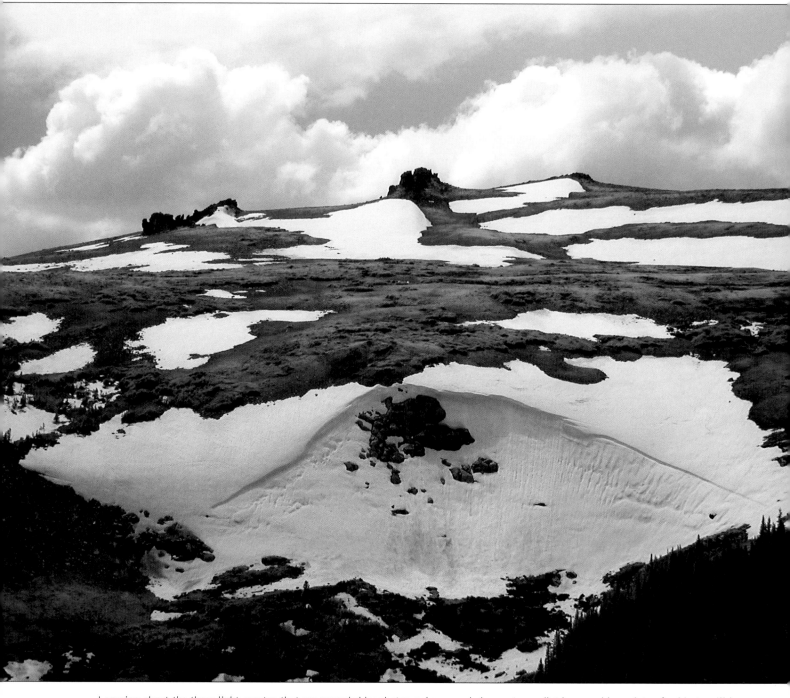

Learning about the three light spectra that are recorded by photographers can help you to predict how a wide variety of subjects will be captured in infrared. This topic will be covered in detail in chapter 8. Photograph by Robert Knuff.

Chapter 2

FILM PHOTOGRAPHY

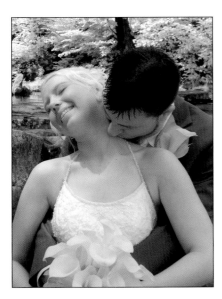

Whether you shoot film or digital, capturing images in infrared allows for a new form of creative expression that both you and your clients will enjoy. Photograph by Patrick Rice.

While digital capture offers many advantages over film in both infrared and traditional film photography, many photographers still occasionally use film. There is nothing wrong with shooting film for any assignment. Film will be with us for many years to come.

Since many readers will likely have no background with shooting infrared film images and will need some basic information on the topic before moving on to the next chapter, I've included some essential film facts here.

Photographers who are in the midst of making the transition to digital may find this chapter of interest as well. However, if you're inclined to leave film in the dust, it's okay to proceed to chapter 4.

FILM CHOICES

In our studio, we now rely solely on digital capture. In the days when we were shooting film, though, we experimented with Kodak High-Speed Infrared and Konica 750nm Infrared, and found we preferred the results we achieved with the Kodak film for many reasons. First, it is the most infrared-sensitive film available for photography. (Visible light is measured between 400nm–700nm, and this emulsion records down to nearly 900nm.) Second, the Kodak film is a "faster" film than the Konica film. All things being equal in a scene, the starting point for exposure with the Kodak film is two stops faster (more light sensitive) than for the Konica film.

▶ **KODAK FILM LACKS AN ANTIHALATION BACKING, AND THE PHOTOS CAPTURED ON THIS FILM HAVE AN OTHERWORLDLY, ETHEREAL GLOW.**

The Kodak High-Speed Infrared film is only available in 35mm and sheet film. We only used the 35mm variety. Kodak film lacks an antihalation backing, and therefore, the photos captured on this film have an otherworldly, ethereal glow. We really like that halation and feel it adds to the dreamlike quality of infrared images.

The Konica 750nm Infrared film is available in both 35mm and 120 formats. This film has peak sensitivity at 750nm and extends just beyond that point. In other words, this film is not as sensitive to infrared wavelengths. The Konica film has a built-in antihalation layer that prevents the images from exuding that "glowing" aspect that you see when shooting with Kodak infrared film.

Maco IR 820c, the newest true infrared film on the market, boasts low grain and has an antihalation backing. Its infrared sensitivity extends to 820nm. This film is available in 35mm, 120, and 4x5-inch formats. It is now available in the United States and Europe.

Both Ilford and Agfa make a pseudo infrared film. Neither is an infrared film—they are both panchromatic films with extra sensitivity in the red range.

The infrared effect can be dramatic or subtle depending on your choice of filtration and the quality of light falling on the scene. Photograph by Patrick Rice.

FILM HANDLING

Kodak and Maco infrared film should be kept in the refrigerator or freezer prior to use. Allow the film to slowly warm to room temperature (about two hours) when taking it out of refrigerator to prevent condensation.

Loading and Unloading. Both Kodak High-Speed Infrared and Maco IR 820c film must be loaded and unloaded in absolute darkness. The film comes in a light-tight, black plastic film container, to which it must be returned after it has been exposed and removed from the camera.

To ensure absolute darkness, film loading and unloading should ideally be done in the darkroom. If a darkroom is unavailable, you can

use a film-changing bag to load and unload your film. I highly recommend that every photographer carry a changing bag with them on all jobs just in case they need to open any camera and any film during the shoot.

The film's sensitivity also requires that you must be very familiar with your camera's loading mechanism, because, in absolute darkness, you have only your sense of touch to rely upon. Over the years, many photographers have admitted to me that they inadvertently misloaded and then shot their infrared film without it ever passing through the camera. Some of the older 35mm cameras automatically reset the counter to the first frame once the back has been opened, and they may not have a film load indicator on the camera body. Imagine the disappointment these photographers must have felt when they went to unload their infrared film and discovered it was never properly loaded!

▶ IT IS IMPORTANT TO NOTE THAT INFRARED FILM CAN BE FOGGED WHEN USED IN SOME OF THE POPULAR AUTOFOCUS CAMERAS. . . .

It is important to note that infrared film can be fogged when used in some of the popular autofocus cameras since they use an internal infrared beam for film spacing.

Konica film is slightly less sensitive and can be loaded, unloaded— and processed—in subdued light.

Processing. When it comes to processing, infrared film is a little more complicated than processing traditional color or black & white. Again, both Kodak and Maco film must be processed in absolute darkness—as even illumination from safelights or infrared lights can result in fogging. Whenever you have to do any loading or processing in the

Shooting infrared film requires advanced planning. Both Kodak and Maco films must be kept in the refrigerator or freezer and slowly brought to room temperature. Photograph by Patrick Rice.

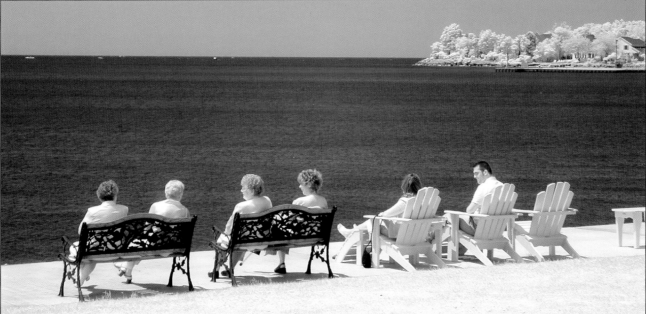

dark, there is a higher chance of error on the part of the photographer/lab technician. Many photographers have told me that they have taken their infrared film to their commercial color lab, given the film to the person at the counter, and watched in horror as the clerk popped open the 35mm canister in the blink of an eye, just like they would with any roll of "normal" film. The only problem is, this time the clerk had just exposed their infrared film to light and possibly ruined all of their photographs!

High Temperatures. Infrared film is very sensitive to high temperatures. It is important not to leave a camera loaded with infrared film in the car on a summer day when the inside temperature can soar to

When shooting film, you should ideally load and unload your film in the darkroom. If a darkroom is unavailable, you can use a film-changing bag to load and unload your film. Photograph by Jacob Jakuszeit.

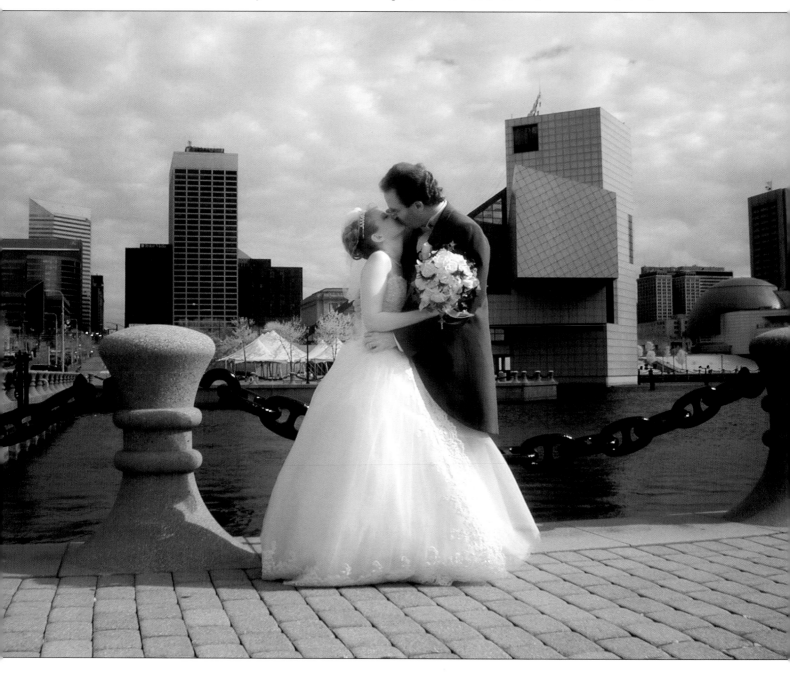

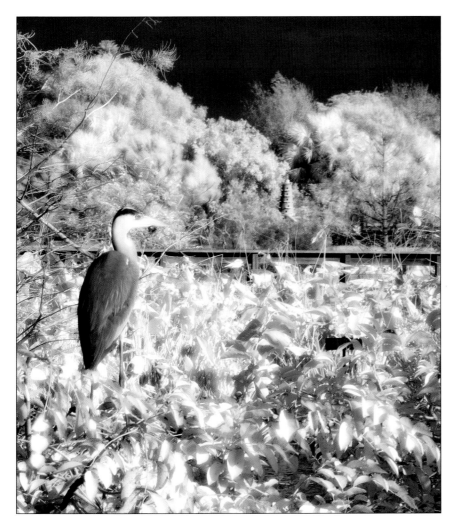

Whether you use film or digital capture, this characteristic glow is part of infrared's charm. Photograph by Barbara J. Ellison.

over 100 degrees. This high temperature can cause your infrared film to fog and lose contrast. When shooting weddings or portraits on location, I had to carry the infrared film camera with me at all times during the warmer months of the year—even if I wasn't using the camera. Another problem for wedding and portrait shooters using infrared is that it is impractical to shoot more than one roll of infrared film at a single site since the film must be handled in the dark (Kodak and Maco) or in subdued light (Konica). I carried a film-changing bag with me for many years, but I usually did not have the time to change rolls of infrared during hectic wedding day coverage.

CAMERAS

We've used both medium-format cameras and 35mm cameras to shoot Kodak 35mm infrared film. With our Mamiya 645 Pro TL cameras, we used the optional 35mm film back and loaded or unloaded the infrared film in absolute darkness. In addition, we used both older and newer 35mm camera bodies to shoot Kodak infrared film. If you'll be using an older 35mm camera, it is important to have the film back's light seals checked before shooting any film. Dried-out light seals can allow some light to pass through the back and create fogging on the Kodak 35mm infrared film. Some of the newer autofocus 35mm cameras have a built-in infrared LED to count the film's sprocket holes for film transport purposes. This is especially true with many of the Canon EOS cameras. If you use infrared film in these bodies, you will experience some film fogging on the bottom of the frame from these internal sources of infrared light.

▶ **IF YOU'LL BE USING AN OLDER 35MM CAMERA, IT IS IMPORTANT TO HAVE THE FILM BACK'S LIGHT SEALS CHECKED BEFORE SHOOTING ANY FILM.**

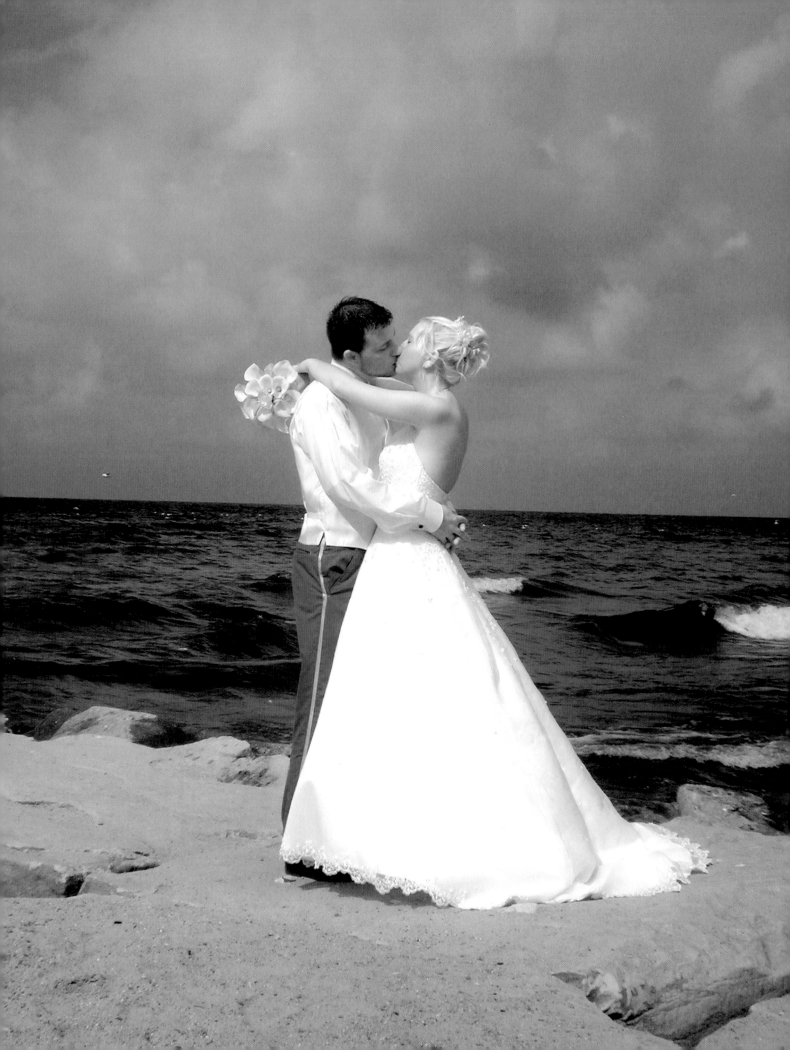

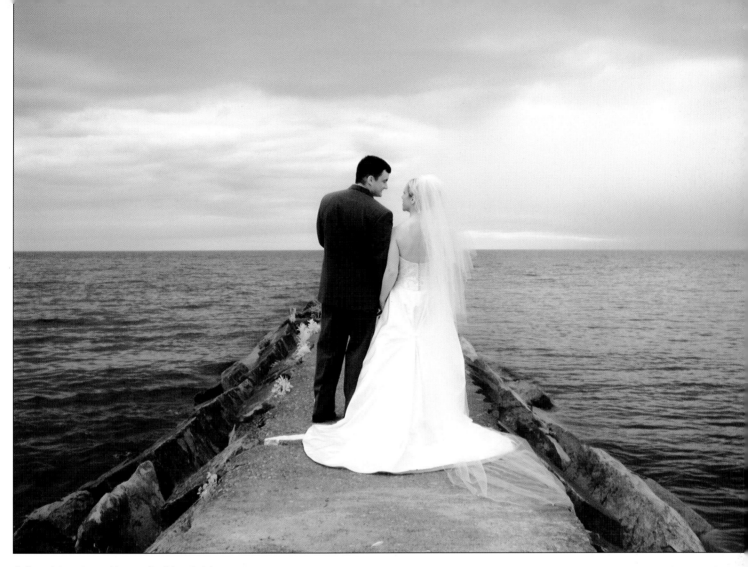

Infrared imaging adds a refreshing twist to black & white imaging that seems to better capture the cherished moments the couple shares than does a more traditional approach. Photographs by Patrick Rice.

FILTERS

As with digital, when using infrared film it is necessary to use filters to block most of the infrared light. With Kodak infrared film, you can primarily use a #25 red filter (basic red) in front of the lens and get very good results. Trees, grass, and other foliage are recorded as very light gray or white, and blue skies can be nearly black with the Kodak film and a #25 filter. This red filter has a $2^1/_2$-stop filter factor, so the exposure must be adjusted accordingly.

You can also use a #87 filter to block all visible light. This filter is opaque, and you must focus and compose your image before placing the filter in front of your camera lens. It has about a 5-stop filter factor.

For more information on filter factors, see page 60.

EXPOSURE

Infrared film does not have a true ASA or ISO setting. Light meters are of little use because they are made to measure visible light, not infrared (invisible) light. With all infrared film, the exposure outdoors will depend on the natural lighting conditions present. On a bright, sunny day, with the subject standing in the sun, a starting point for exposing

your Kodak infrared film would be f11 at $^1/_{125}$ with the #25 red filter in front of the lens. With the Konica infrared film, the starting point is f5.6 at $^1/_{125}$—two full stops slower than the Kodak film. On a cloudy day, open up the lens two stops with either film.

With film, it is important to bracket your exposure—typically down one stop and up one and two stops—to ensure a perfect negative for printing. This is especially important when capturing a once-in-a-lifetime event like a wedding; it is far less costly to take a couple extra exposures than it is to ask the bride and groom to go back and try to re-create an image because the exposure wasn't acceptable.

Remember that exposure will change with a change in the subject's distance from the camera. The farther away the subject, the faster the film rating and vice versa. With the subject 25–30 feet away, you may start at f11 at $^1/_{125}$. If the subject were less than 10 feet from the camera, you would need to open up to f5.6 at $^1/_{125}$.

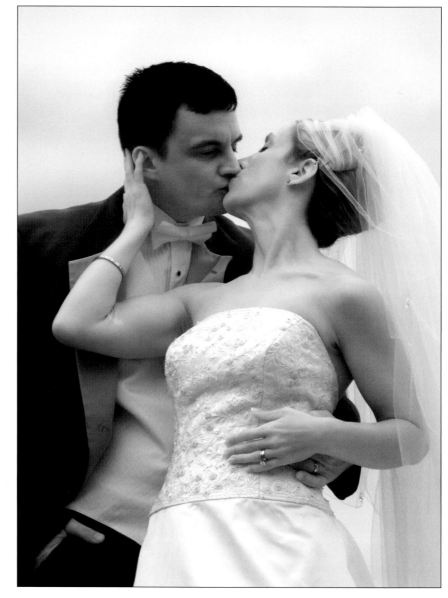

With film, it is important to bracket your exposure—typically down one stop and up one and two stops—to ensure a perfect negative for printing. Photograph by Patrick Rice.

FOCUS CONSIDERATIONS

Because the infrared focal point is farther from the camera lens, the lens must be moved slightly farther from the film or sensor to focus an infrared image. This focus difference is most critical when using filters to block all visible radiation.

Many lenses are marked with a small red line or "R" to show you the infrared readjust mark. After you focus the lens on your subject, you must move that focus point back to the infrared mark to have the infrared image properly focused on the film.

DIGITAL VS. FILM

Photographing sequences like this one is more economical with digital capture than with film. Photographs by Patrick Rice.

It is important for photographers to understand the differences and similarities of shooting with infrared films or creating digital infrared images. While infrared theory is, for the most part, the same for either medium, there are many distinct advantages to shooting digitally. These benefits are outlined below.

INFRARED SENSITIVITY

Film. Infrared films can record up to the wavelength of light that the emulsion is sensitized for. All infrared films use dyes to extend their sensitivity range beyond red and into the near-infrared spectrum. The Kodak infrared film has sensitivity to around 900nm. With the aptly named Konica 750 infrared film, the emulsion is sensitive to around 750nm. This is one reason why infrared images made with Kodak film have more of the infrared look than do those made with Konica. The new German-made infrared film, Maco IR 820c, is sensitive to around 820nm. Ilford and Agfa make pseudo infrared films, but the aforementioned films offer better quality.

Digital. As will be explained in chapter 4, professional-quality digital cameras have a hot-mirror filter installed in front of the camera's sensor. Depending on its strength and efficiency, this filter usually blocks much or all of the electromagnetic spectrum shorter than 400nm and longer than 700nm. The wavelengths shorter than 400nm are in the ultraviolet range and are not needed or wanted in infrared photography. The wavelengths longer than 700nm, however, are in the near-infrared range, the range in which infrared photographers want to record. Some early digital cameras did not have strong hot-mirror filters and thus were able to record into the infrared range (especially with the addition of #25 or #87 filters). Just like with infrared film, it is important to filter out much if not all of the visible spectrum so those wavelengths of light do not overpower the image.

Some enterprising photographers have their camera's hot-mirror filter removed from their cameras and replaced with clear glass. This simple and relatively inexpensive technique will render the camera useless for anything other than black & white infrared imaging, but it vastly improves the quality of the images. With a #25 filter added to the lens of the modified camera, I've created images that mimic the effects achieved with Kodak infrared film (but with numerous advantages over traditional infrared imaging).

THE INFRARED GLOW

Film. One of the big differences between Kodak and Konica infrared films is that the Kodak film does not have an antihalation layer. The lack of this protective layer is one of the reasons why the film is so sensitive to light and so easily fogged. It is also the reason why photographs taken with Kodak infrared film sometimes have a soft glow to them. This glow is actually halation. Creative infrared photographers have used this glowing effect to their advantage and created soft, beautiful, dreamlike images with Kodak film. The Konica film, on the other hand, has an antihalation layer—as does the new German-made film, Maco—so it doesn't share this quality or look.

Digital. Since digital cameras lack antihalation filters, the ethereal glow that occurs when an image is captured on Kodak film is also found in digital infrared images. If you'd like to digitally create the glow using a scanned Konica or Maco film image or to finesse the degree of glow inherent in your digital image, you can simply go to Filter>Distort>Diffuse Glow or Filter>Blur>

The ethereal glow that occurs when an image is captured on Kodak film is also apparent in digital infrared images. If you'd like to digitally create the glow using a scanned Konica or Maco film image, or to finesse the degree of glow inherent in your digital image, you can exercise your Photoshop skills, as outlined on page 109. Photograph by Patrick Rice.

While adding noise in a digital image can be done to mask pixelization, it also gives the digital image a more film-like, traditional infrared look. Photograph by Tony Zimcosky.

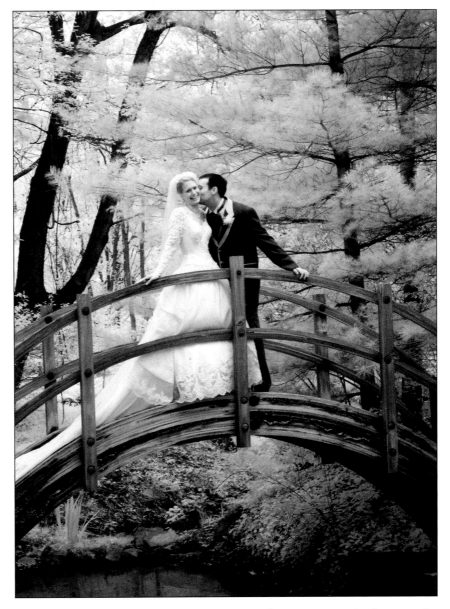

Gaussian Blur in Photoshop. For more information on the latter technique, see page 109.

GRAIN

Film. All high-speed films are grainier than slower films. Black & white infrared film tends to be grainiest when subjects are positioned in the shade or when the shot is made on overcast days, though minimal grain will appear in the print if the image is captured in full sun.

For many photographers, grain is a positive aesthetic advantage in an infrared image; it contributes to the otherworldly look.

Digital. Digital infrared photographs do not have the high grain that's apparent in Kodak infrared film images. If a photographer wants their digital infrared images to look more like that of Kodak infrared film, they simply need to use the tools available to them in Photoshop.

Since digital cameras provide small image files, with prints over 16 x 20 inches in size, pixelization is an unwelcome result. I routinely add noise to reduce the appearance of pixelization when I need to make larger images for a client.

Adding noise lends a slightly different look to an image than does adding grain. If you experiment with each, you'll soon identify the difference between the two effects. To add noise, go to Filter>Noise>Add Noise. You'll need to enter a number in the Amount field, click on Gaussian Blur, and make sure that the Monochromatic option is selected. To add grain, go to Filter>Artistic>Film Grain, and adjust the Grain, Highlight, and Intensity sliders until you get the effect you want.

The ability to add just the right about of grain or noise to the image is another great advantage of shooting digitally.

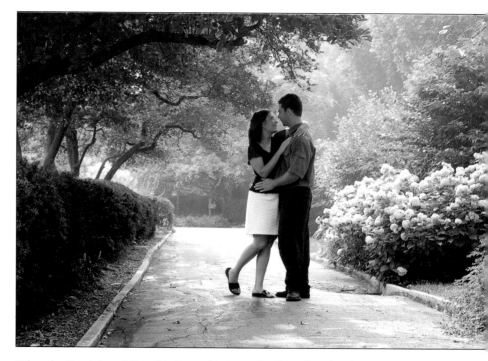

When shooting infrared film, it is impossible to predict the end results. Consequently, some photographers might unknowingly pass up creating a stunning image like this one. Photograph by Michael Ayers.

IMAGE PREVIEWS

Film. With film, photographers spent time talking about how we expected the scene to look in infrared. Because we cannot see infrared light, predicting its effects was difficult at best. Once we shot a scene we could compare the final results and make mental notes on how things would record when it came time to shoot similar scenes in similar conditions. In other words, our experience provided us with certain expectations that were beneficial when determining how to create the best infrared photograph. However, as many of us learned, not everything about a scene or subject was always predictable. Despite our best efforts, questions about how eyes would photograph, how clothing would be recorded, and how deep the shadows would be were never answered until after the film was processed and printed.

To counter this problem, I even acquired an infrared night-vision scope that I fitted with a red filter so that I could catch a glimpse as to how the scene might look in my infrared photographs. (Night-vision scopes show the scene in green light because the human eye can distinguish more shades in the green range than any other color, thus

making it the most useful for enhancing vision.) With a red filter placed on the scope, objects that are often hidden to the eye can become visible. For instance, hunters can see animals in the brush or birds in trees because they will show up darker than the surrounding foliage, which is rendered white in infrared. I highly recommend a night-vision scope for infrared photographers who use film.

Digital. With digital infrared photography, the camera's LCD screen shows me the image immediately after I have taken it—a clear benefit over using film. I can also use the camera's playback mode to hold the image for long periods of time and can use my 2x magnifying loupe (specifically designed for digital cameras) for a quick inspection of the overall image at twice the magnification of the screen image. Most digital cameras also allow for magnifying the image on the LCD, which allows you to see details in the recorded image. The guesswork is completely eliminated!

As a portrait and wedding photographer by trade, it is a great advantage to be able to show the client what their infrared images look like immediately after capture. The clients are excited about these unusual and striking images and are more likely to purchase more photo-

Whether you're shooting infrared images of tradtional color or black & white photos, you can share your digital images with the couple on site. Doing so will drive their excitement and allow you to fine-tune any composition, focus, or exposure problems to ensure a salable image. Photograph by Patrick Rice.

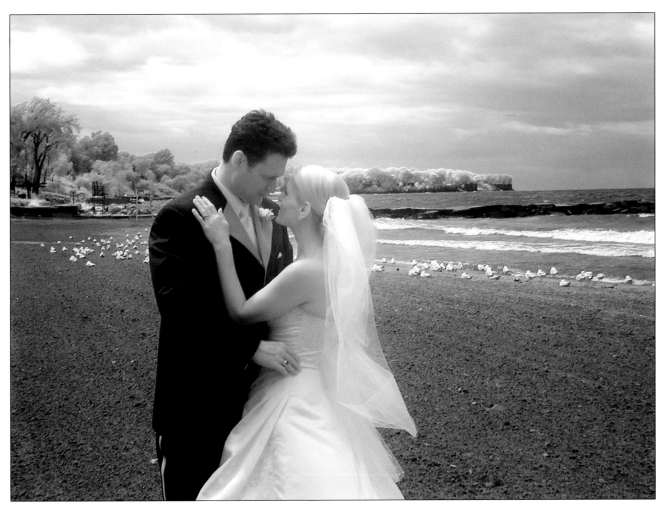

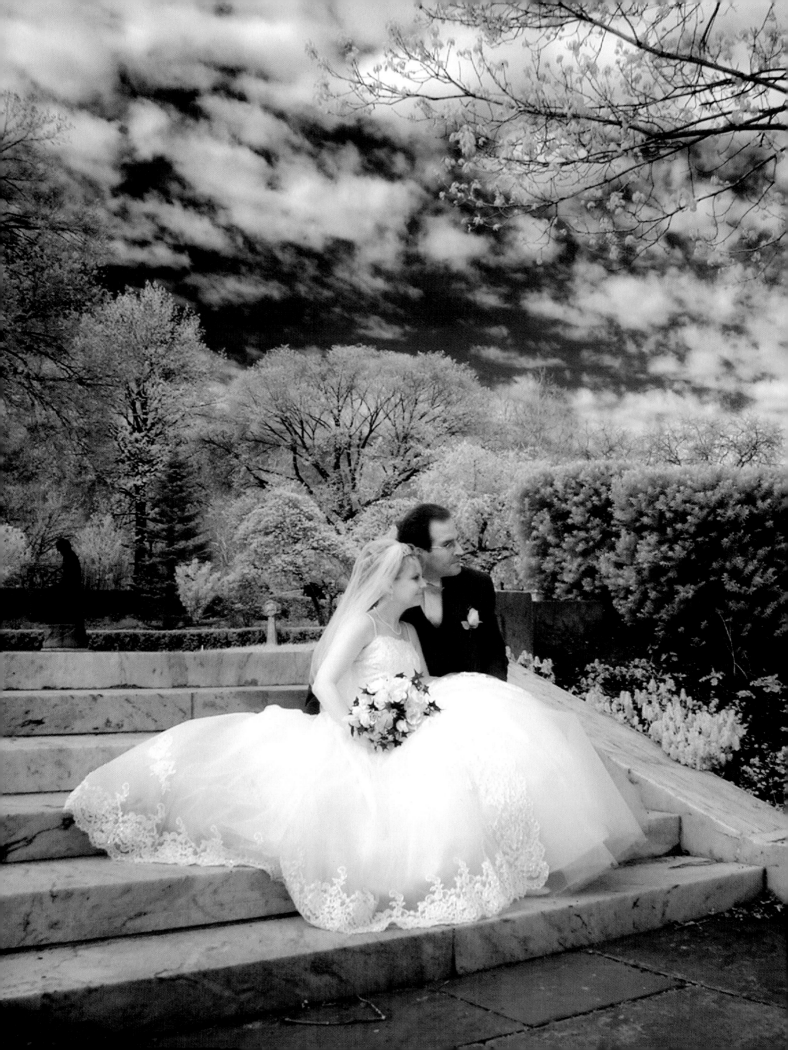

graphs from the sitting or wedding. As an added bonus, being able to show customers their images instantly also increases their confidence in you as an artist. It relaxes them and makes them feel better about the photographic experience.

The LCD feature allows for more than a close scrutiny of the captured image, however. While there are no available light meters made to measure the amount of infrared light in a scene, as a digital photographer, I can always view the histogram of the infrared images that I record to ensure that I am getting a correct exposure. Again, no more guesswork. If the exposure isn't correct, I can make an adjustment and take the image again. I can even erase the file so it doesn't take up space on my CompactFlash card. (We'll cover histogram usage throughout this book.)

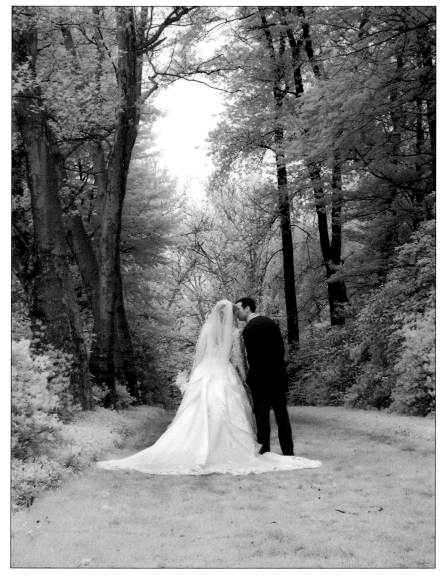

Any photographer who is familiar with infrared film is also familiar with its high price. Adding an infrared cutoff filter to a digital camera is a far more economical choice. Above photograph by Tony Zimcosky. Photograph on facing page by Jacob Jakuszeit.

COSTS

Film. Any photographer familiar with infrared film is also familiar with its steep price tag. Each roll of Kodak infrared film costs $10–$16. When you consider that most photographers bracket infrared film a few stops, and therefore capture only 9–12 different images per roll, you'll see that the cost is $1 per shot on every roll!

On top of that, you must add in the cost of developing each roll of film. Commercial color labs can be quite expensive when asked to handle a film type that they rarely encounter. If you are processing the film yourself, you must consider the costs involved in using your tanks and chemicals, as well as your time for each roll of film.

Digital. With digital infrared imaging, like all digital imaging, there is obviously no film cost. Additionally, you only print the best exposures—you don't have to develop every image in hope

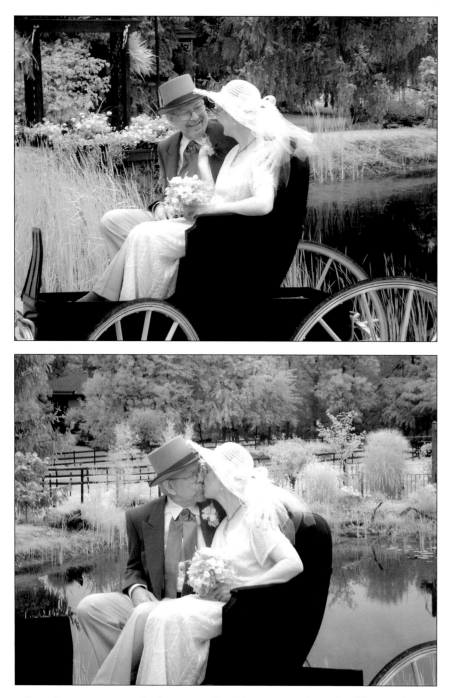

Take one image or twenty; with digital infrared capture, you can experiment freely and create storytelling images your clients will cherish. Photographs by Travis Hill.

of getting some good photographs. The cost savings in film and processing will quickly pay for a digital infrared camera.

HANDLING

Film. As was outlined in chapter 2, loading, unloading, and processing infrared films is complicated. With Kodak and Maco films, absolute darkness is required when handling film. With Konica, subdued light is a must. Every moment counts, and switching out one roll of film for another is a waste of time and, even with a film changing bag, loading, and unloading infrared film is a hassle.

Digital. When shooting digitally, film handling is no longer an issue. With digital infrared cameras, I can shoot as many images as I want. During some weddings, for instance, I have taken more than 100 infrared photographs—something that would never be possible with infrared film.

IMAGE MANIPULATION

Film. Digital manipulation is not the sole domain of digital photographers. In fact, once film is scanned, the image can be digitally enhanced in Photoshop.

Digital. While film must be digitized before it can be digitally enhanced, shooting digitally puts you on the fast track to fine-tuning your images. With software programs like Photoshop, I can enhance digital infrared images in seconds. Images that were underexposed can easily be adjusted through Levels controls. The overall contrast of a digital infrared image can be increased if the image is too flat. While digital infrared is grainless, I can add grain or noise in Photoshop to achieve just the right look for any image (see page 78).

We have found that using Auto Levels in Photoshop gives a very nice and subtle representation of pseudo color-infrared photos like this one. Pseudo color-infrared imaging is discussed in chapter 6. Photograph by Travis Hill.

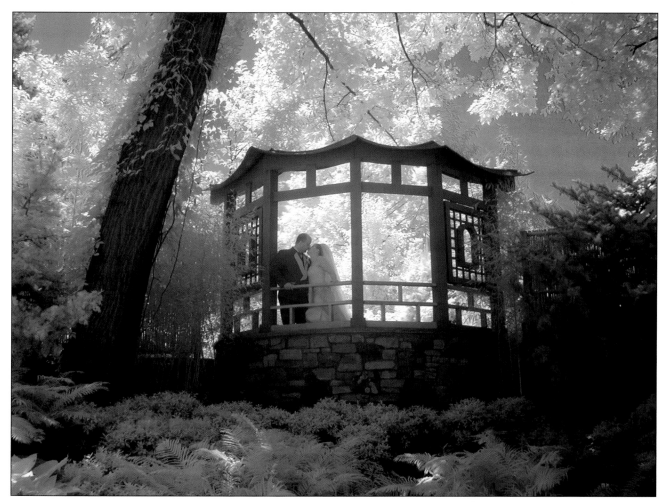

Chapter 4

CAMERAS

DIGITAL INFRARED CAMERAS

Once bitten by the infrared bug, a photographer's first question is typically, what camera do I use? The good news is that most consumer-grade digital cameras are sensitive to infrared (and those that are not can be modified and made usable). While it is impossible to cover the specifics of each infrared-sensitive digital model on the market, some basic features of several cameras will be discussed here. (Note: While there are digital cameras that are specifically made for recording infrared radiation, they

▶ **THE FIRST STEP IS ENSURING THAT YOUR CAMERA IS CAPABLE OF CAPTURING NEAR-INFRARED WAVELENGTHS.**

are primarily used in surveillance and forensics, and by the military. Their high price tag [$20,000+] makes them an impractical choice for most hobbyists and professional photographers.)

TESTING YOUR CAMERA

As mentioned, the first step toward taking digital infrared images is ensuring that your camera is capable of capturing near-infrared wavelengths. Fortunately, finding out whether or not your camera model is infrared-sensitive is easy. In fact, a crude but simple test of a digital camera's infrared sensitivity can be done with any television or stereo remote control. Simply point the remote at your digital camera and press any button. If you can see the glow of the infrared beam being sent by the remote in your camera's LCD, or if it is visible in the final image, then the camera is indeed sensitive to the infrared range and can record infrared radiation to some extent. The brighter and clearer the projected beam, the better the camera will be able to capture infrared images.

If your camera fails this simple infrared test, all is not lost—you can easily have your camera modified (we'll discuss that option shortly).

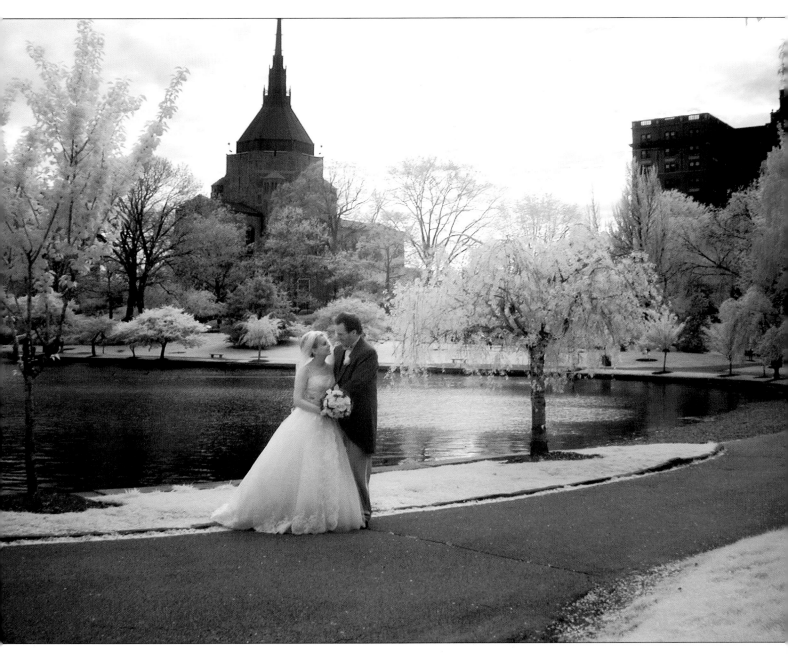

Determining whether your camera is infrared-sensitive is easy. And once you do, you'll be on the road to making the average image extraordinary. Photograph by Jacob Jakuszeit.

If you're in the market for a new camera with infrared sensitivity, you'll find several models listed in this book. As new models become available, you may need to get advice from someone experienced in infrared, since the sales literature available for most cameras does not describe infrared sensitivity.

WHAT MAKES A CAMERA INFRARED-SENSITIVE?

To understand why some cameras can shoot into the infrared range and others cannot, you must first understand how digital cameras are made and how infrared images are recorded. If you're content to know that your camera is sensitive to infrared wavelengths and want to cut to the chase and put it to use, the next step is to learn about filters (see

chapter 5), since an infrared-sensitive camera alone does not a good infrared image make.

If you're curious about the more technical side of digital cameras as they relate to infrared, you'll find much food for thought here.

In digital cameras, infrared performance is dependent upon a combination of lens speed, infrared sensitivity (which is determined by the CCD or CMOS chips), the efficiency of the camera's infrared hot-mirror filter, and the image quality at higher ISO settings.

Lens Speed. The lens speed, or the largest aperture that your camera can open up to, determines in part the quality of your final image. Since many cameras must be filtered with an opaque filter that blocks light from the visible spectrum from being recorded in the camera, shutter speeds can be quite long. Understandably, an ability to use a

In digital cameras, infrared performance is dependent upon a combination of lens speed, infrared sensitivity (which is determined by the CCD or CMOS chips), the efficiency of the camera's infrared hot-mirror filter, and the image quality at higher ISO settings. Photograph by Patrick Rice.

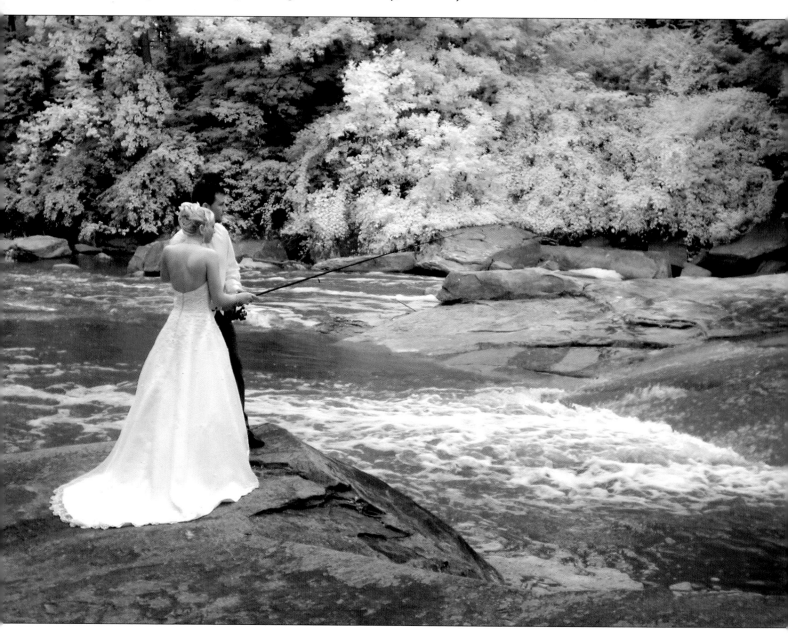

Early digital cameras had ineffective hot-mirror filters, making them good candidates for digital infrared imaging. Photograph by Patrick Rice.

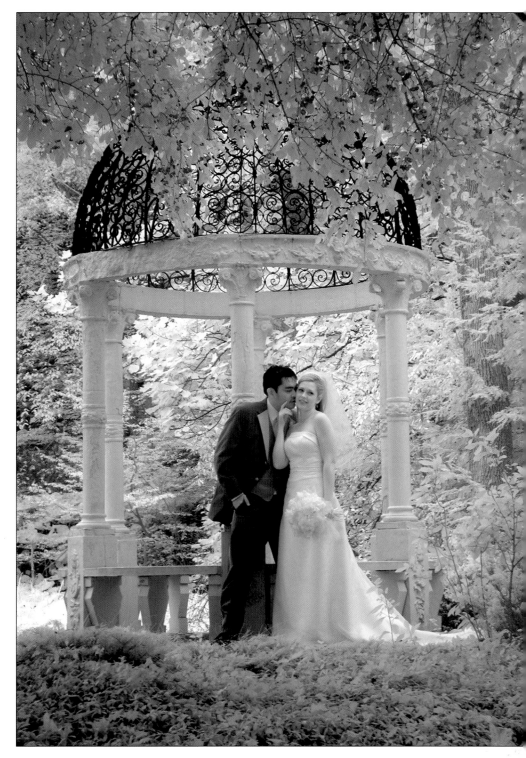

wider aperture (or "a fast lens") will allow you to select a shorter shutter speed. This is an obvious benefit for portrait photographers, who are typically concerned with potential subject movement.

CCD or CMOS. Prior to 1999, when 3-megapixel (MP) CCDs hit the market, any given digital camera on the market was likely to be infrared-sensitive. In recent years, preventing or diminishing the recording of infrared wavelengths (with a hot-mirror filter) has been a

concern for manufacturers, as doing so produces an image with less pixelization. Not to worry, though: with proper filtration and/or modification, even a camera with a more "efficient" new CCD or CMOS can record infrared images.

Hot-Mirror Filters. With digital cameras, manufacturers are always working to give the photographer the best possible image file. In this mission, technicians discovered that digital image capture is improved by blocking infrared light, which contaminates the visible light being captured on the digital media and degrades image quality. They discovered that the solution was to install a hot-mirror filter to block the transmission of most or all infrared light to the camera.

▶ **HOT-MIRROR FILTERS, ALSO REFERRED TO AS "CUTOFF" FILTERS, REFLECT INFRARED WAVELENGTHS AND TRANSMIT VISIBLE LIGHT.**

Hot-mirror filters, also referred to as "cutoff" filters, reflect infrared wavelengths and transmit visible light. While early hot-mirror filters were not terribly efficient, the latest hot-mirror filters transmit over 85 percent of the wavelengths in the visible light spectrum (400–700nm) and reflect (block) over 90 percent of the wavelengths in the near-infrared spectrum (700–1200nm). Since cameras containing such effective filters *reflect* the majority of infrared light, they cannot be used to create infrared images.

ISO Settings and Image Quality. With all digital cameras, the higher the ISO, the greater the amount of noise in the image. As a general

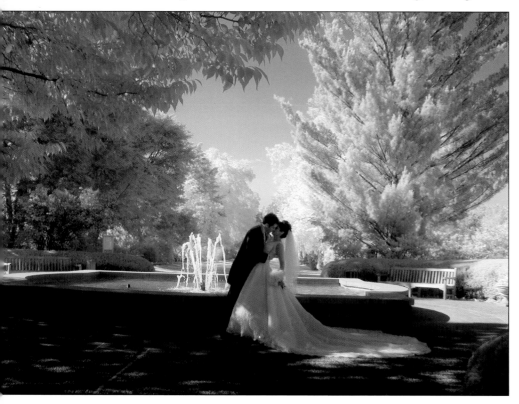

Without filtration, the camera's image sensor would have recorded visible light, diluting the infrared effect seen in these images. Photographs by James Williams.

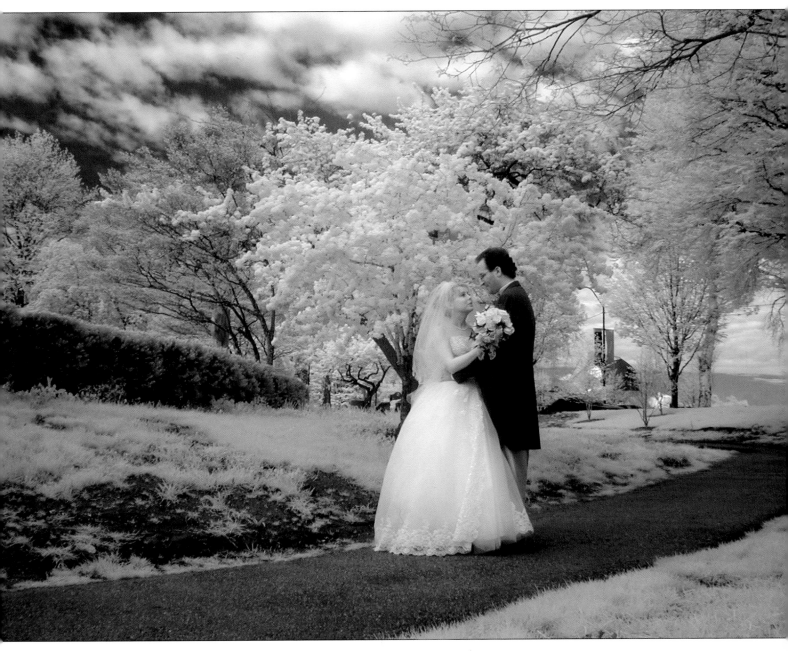

Higher-megapixel cameras produce better image quality at high ISO settings. Photograph by Jacob Jakuszeit.

rule, the more megapixels the digital camera sensor has, the better the image quality at higher ISO settings. While better-quality cameras give more acceptable results at high ISO settings than less expensive models, I rarely shoot above ISO 800 so as to maximize image quality.

POPULAR MODELS

As noted above, manufacturers now improve the image-capture quality of their cameras for mainstream photographers by installing hot-mirror filters to block infrared light.

Some cameras, however, like the Nikon Coolpix 950 and the Olympus C 2020 Z, were manufactured prior to the advent of the more effective infrared-blocking/inhibiting filters. With this inherent sensi-

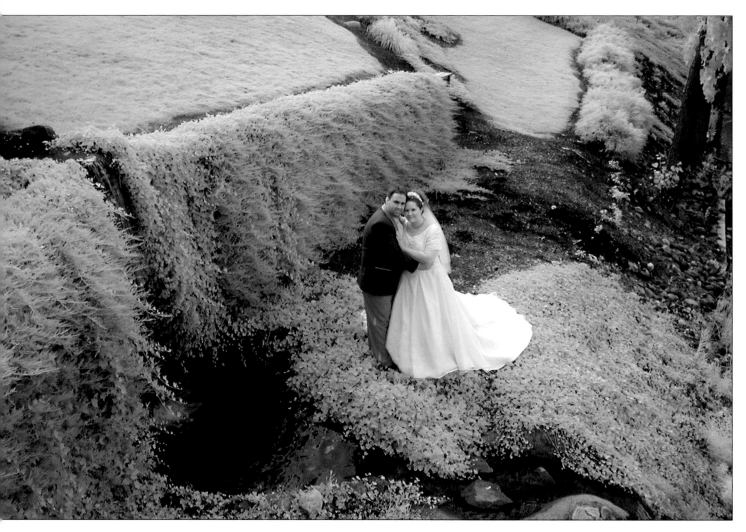

tivity to infrared light, they make excellent candidates for digital photography once they are fitted with external filters to block the wavelengths in the visible light spectrum. Later digital models from these and other manufacturers are equally usable for infrared photography (though some require modification; more on that shortly). For these, selecting the appropriate level of filtration to suit your specific camera, your tastes, and your shooting style may require a little trial and error.

A brief synopsis of some of the models popular with infrared photographers appears below. (The extensive information about the Nikon 950 and 990 that appears throughout this book is a result of my personal experience with the two models.)

I use a modified Nikon 990 Coolpix camera to create infrared images. Modifying your camera for enhanced infrared sensitivity will increase your odds of success. The technique is covered in detail later in this chapter. Photograph by Patrick Rice.

▶ **SELECTING THE APPROPRIATE LEVEL OF FILTRATION TO SUIT YOUR PARTICULAR CAMERA MIGHT REQUIRE A LITTLE TRIAL AND ERROR.**

The Nikon Coolpix 950. This model was built around the Sony 2.11MP CCD, which is quite sensitive to infrared wavelengths. In addition, it was manufactured before the advent of today's more effective hot-mirror filters. Exposures are relatively slow using the #87 opaque

filter with the Nikon Coolpix 950—they range from about $1/_{15}$ to $1/_{2}$ second in the sunlight and even longer in overcast conditions. This camera has both a color and a black & white mode; the latter feature is another reason why it is a good candidate for infrared photography (see "Shooting in Black & White Mode," on pages 71–72).

The Nikon Coolpix 950 has a 256-element matrix metering system. It can be used in four modes, including programmed autoexposure, shutter-priority auto, aperture-priority auto, and manual exposure. The built-in zoom lens gives you "true" (35mm equivalent) focal lengths from 38–115mm.

The Nikon Coolpix 950 offers several size and quality modes. Like many other digital cameras, it stores images as JPEG (short for Joint Photographic Experts Group) files. The camera has three modes of JPEG file compression: basic, normal, and fine—ranging from the most compression to the least compression. The less compression, the better the image quality upon enlargement of the image. You can also shoot in the uncompressed Hi mode in TIFF format for the best quality possible. The only drawback to using the better-quality modes is that the larger file sizes result in a reduction of the total number of images that can be stored on a given memory card. For this reason, I use large-capacity Lexar CompactFlash cards with this camera.

▶ NIKON MAKES A SCREW-ON FISHEYE ADAPTER LENS FOR THIS AND THE OTHER MODELS IN THEIR COOLPIX LINE OF CAMERAS.

Another important feature for me in selecting this camera is compatibility with my fisheye lens. Nikon makes a screw-on fisheye adapter lens for this and the other models in their Coolpix line of cameras. This is important because I am able to achieve a "true" fisheye image on a digital capture system. Other digital cameras either do not have a fisheye lens as an option or have a multiplication factor of about 1.5 on the SLR lenses used with the camera (increasing the effective focal length of the lenses used on the camera). For example, with the Nikon D1, the standard fisheye lens no longer produces the true fisheye appearance in the images. By attaching the Nikon fisheye adapter lens to the Nikon Coolpix camera's zoom lens, you can get "true" (35mm equivalent) focal lengths from 8–24mm!

The Nikon Coolpix 990. Manufactured after the 950, this model contains a highly effective hot-mirror filter and is therefore not very sensitive to infrared light. This model is equipped with a 3.34MP CCD. While the 950 used to be my camera of choice when shooting infrared, I now use the Coolpix 990 for its larger file size. However, due to the highly restrictive hot-mirror filter, the camera should be modified to enable the effective capture of infrared images.

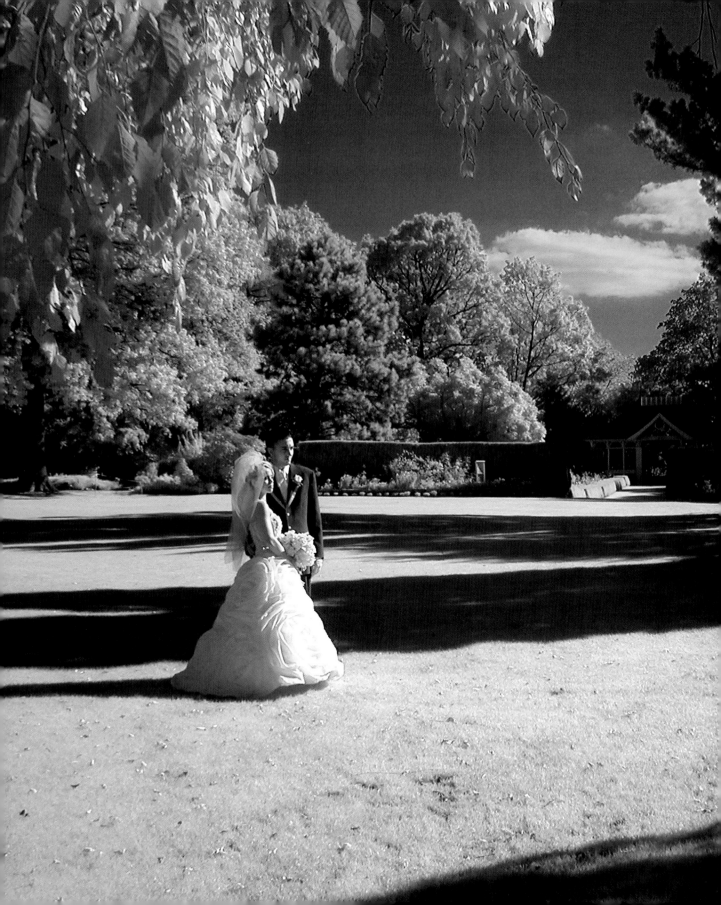

While scanning an image taken with a film camera is an option, using a digital model makes it easier still to use Photoshop to apply creative digital effects like the one shown on this page. Photograph on the facing page by Robert Knuff. Photograph on this page by Patrick Rice.

Nikon D100. This camera has a 6.1MP CCD. It accepts interchangeable lenses, so lens speed is not a factor in the quality of its capture of infrared images. This model has a moderately effective hot-mirror filter.

Nikon D1X. This camera has a 5.33MP CCD. Like the D100, it accepts interchangeable lenses, so lens speed is not a factor in the quality of its capture of infrared images. It also has a moderately effective hot-mirror filter.

The Olympus C 2020 Z. This camera has high-level infrared sensitivity since it lacks an effective hot-mirror filter. Like the Nikon Coolpix 950, this model was built around the Sony 2.11MP CCD, which is quite sensitive to infrared wavelengths. The camera features a

2.5x digital zoom and a fast, f/2.0 lens. It takes acceptable photographs at a high ISO setting.

The Olympus C 4040 Z. While this later model has a more effective hot-mirror filter than its predecessor, it does offer other infrared-friendly qualities, including a f/1.8 lens and less pixelization at high ISO settings. The camera has a 4.1MP CCD.

The Fuji FinePix S2 Pro. This model has a 6.1MP CCD. The F2 accepts interchangeable lenses, so the lens speed is not a factor in the quality of its capture of infrared images. This model contains *no* hot-mirror filter but, when filtered with a #87 filter, it requires especially long exposures. It is important to keep in mind that since the camera is not equipped with a hot-mirror filter, this model cannot be modified for improved performance.

Canon EOS1D. This camera has a 4.15MP CCD. It accepts interchangeable lenses, so the lens speed is not a factor in the quality of its capture of infrared images. It has a poorly effective hot-mirror filter.

Canon D30. This camera has a 3.1MP CMOS. Because it's an SLR, the camera's lens speed is dependent upon the lens that's attached to the camera. It has a moderately effective hot-mirror filter.

Canon D60. This camera has a 6.52MP CMOS. Because it's an SLR, the camera's lens speed is dependent upon the lens that's attached to the camera. It has a poorly effective hot-mirror filter.

MODIFIED DIGITAL CAMERAS

Early in my digital infrared career, I learned that some photographers were having their Nikon Coolpix 950s and 990s modified for improved infrared sensitivity. I accessed information about the procedure online, then contacted my local camera repair shop, Pro Camera & Video Service (216-661-8666) in Cleveland, Ohio, to make the modification, first on my Nikon Coolpix 950, then later on two 990s. Because they are a Nikon repair shop and are quite familiar with their cameras, they agreed to give it a try. This modification cost $125 and was worth every penny. The results are truly amazing!

▶ **TO MODIFY THE CAMERA, THE TECHNICIAN REMOVED THE HOT-MIRROR FILTER FROM MY CAMERA AND REPLACED IT WITH CLEAR GLASS. . . .**

To modify the camera, the technician removed the hot-mirror filter from my camera and replaced it with a piece of clear glass that was ground down to the hot-mirror filter's exact dimensions. (Unless the filter is replaced with clear glass, the camera will be nearsighted and will not focus sharply.) If you're the do-it-yourself type, you can use photographer James Wooten's documentation of the modification process (facing page) as a starting point for completing the modifica-

People are always asking, "Can I remove the infrared blocking filter to improve the performance of my camera in near infrared range?" The answer is, yes—if you are very brave. I am not the first person to perform this operation. I just had two cameras.

To complete this process, you'll need replacement glass for the filter, a standard glass cutter, and some small screwdrivers. Do not try to complete this process without inserting the clear glass. The camera will be near-sighted without it. I used an optical glass, which has about 85 percent transmission in the infrared and visible range. It took several tries to get the cut right, but it can be done.

If you decide to attempt this modification, you are on your own. You can destroy your camera this way. Also note that the camera will not be good for shooting regular color images after this operation. In case you were wondering, this does void your warranty, so don't blame Nikon.

This images and text presented here merely documents my experience in removing the cut-off filter in a Nikon 950 camera and is not intended to be a guide for the removal of this filter. Not all of the basic steps are included. If you are still brave enough to preform the modification after looking at these pictures, good luck. (Note: The 950 and 990 are almost identically constructed, but some of the wiring and dimensions are slightly different.)

Left—The first step is to remove the batteries, then remove the camera's outer cover, which is easy to remove. You must remove the Coolpix label to access some of the screws. **Center**—Next, remove the front lens cover. **Right**—Finally, the inner cover is removed and everything falls apart.

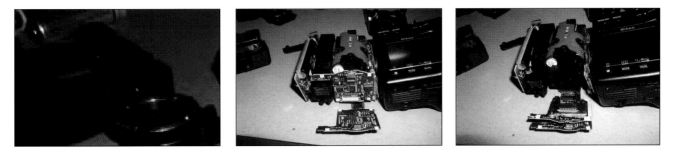

Left—Avoid touching the capacitor on the flash (that long metal tube); it carries a high voltage even when the batteries are removed. **Center**—The back electronic board snaps out of a socket. The underlying board has the CCD mounted on the other side with the infrared cutoff filter. Remove it by removing two screws. **Right**—The filter is mounted in a rubber adapter and must be removed and replaced with the clear filter. Be sure not to leave any fingerprints here.

Left—Comparison of the IR blocking filter (left) and the replacement glass (right). Replacement glass dimensions for the 950 are 11mm x 12mm and 2.5mm thick. **Center and Right**—Now try to put it back together. The camera can (hopefully) be used with a standard infrared filter for high-speed infrared photography. You can use an accessory hot-mirror filter to use the camera in its pre-modified state, but the color may be slightly off (this can be fixed in Photoshop).

tion yourself (you can also view these instructions on James's website, at http://abe.msstate.edu/~jwooten/).

Modifying your digital camera increases its sensitivity to infrared wavelengths, and as a result, you'll produce stronger infrared images. While that in and of itself is a great advantage factor for many shooters, there are other benefits, too. With a modified camera, shutter speeds are faster. Therefore, you'll encounter fewer problems with subject movement during the exposure.

Please note, however, that by removing the hot-mirror filter and replacing it with clear glass, you will severely alter the camera's ability to take pictures in its color mode. In other words, once the procedure is complete, you have a *dedicated* infrared camera.

My friend David, host of a great website, www.IRDigital.net, has a different approach to modifying cameras. He's converted over 75 cameras, including the Canon EOS1D, D30, D60, and Nikon D100 and is currently working on conversions for the Nikon D1, D1x, D1h, and D2h.

To convert the cameras, David removes all the filters mounted in front of the sensor and replaces them with a #87 (opaque) filter, which allows radiation over 800nm (at 50 percent absorption) to pass and blocks radiation that falls in the visible spectrum. The installation of the #87 filter makes the camera's sensor far more sensitive to infrared. For instance, with a

▶ **THESE MODIFIED CAMERAS SHOOT AND VIEW LIKE A NORMAL, UNFILTERED CAMERA, AND IMAGES CAN BE IMMEDIATELY VIEWED ON THE LCD.**

#87 filter in front of the lens of an unconverted D30, the approximate daylight exposure would be 2 seconds at f8 (at ISO 200). In contrast, proper exposure for a converted camera in daylight is $1/125$ at f11 (at ISO 200). This allows the camera to be handheld and permits photographing moving subjects.

Because this opaque filter is placed in front of the sensor, rather than on the lens, these modified cameras shoot and view like a normal, unfiltered camera, and images can be immediately viewed on the LCD display on the back of the camera. (This is not a problem with a Nikon Coolpix camera, since it is a rangefinder-type camera, and the scene is viewed through a window and not the lens itself.) David also sets a custom white balance so images on the modified camera's rear LCD are displayed in black & white (with a slight color shift) although the camera still records a three-channel (RGB) image. Needless to say, this ease of use sure beats the handling and processing concerns inherent in shooting infrared film.

David charges $350.00 for the conversion plus $35.00 for FedEx delivery and insurance. Turnaround time is two to four weeks. This

Infrared imaging is exceptionally flattering when creating portraits. Note the luminous quality of this client's skin. Photograph courtesy of www.IRDigital.net.

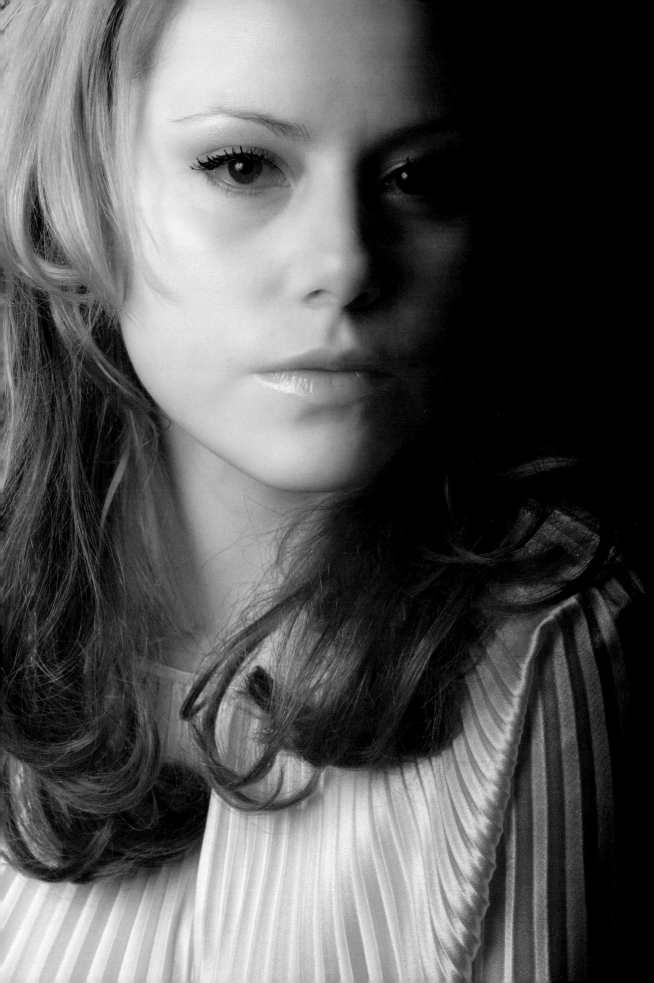

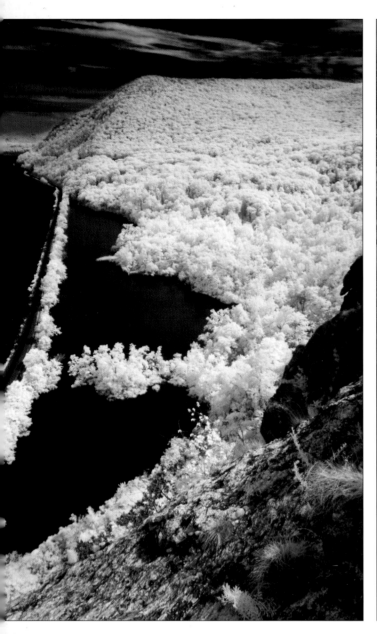

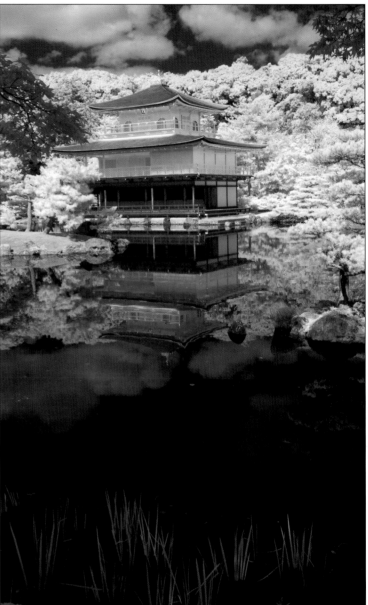

conversion results in a camera that captures black & white infrared images only. The camera can be refitted to capture conventional images, but the cost is very high—around $1,000.00—since the removed filters are irreparably damaged and would have to be purchased from the manufacturer for reinstallation.

When using a modified camera, David shoots in RAW mode and converts his digital infrared files to 16-bit images in Adobe® Camera Raw®. (This plug-in is included with Photoshop CS and is also available as a free download on Adobe's website: visit www.adobe.com.) To fine-tune his images, he uses the plug-in to reduce the saturation to 0. Next, he improves image contrast by moving the shadow slider under the histogram data on the left edge, then moves the brightness slider under the data at the right edge. This gives the best printable image

When using a modified camera, David shoots in RAW mode and converts his digital infrared files to 16-bit images in Adobe Camera Raw. Photographs above and on the facing page are courtesy of www.IRDigital.net.

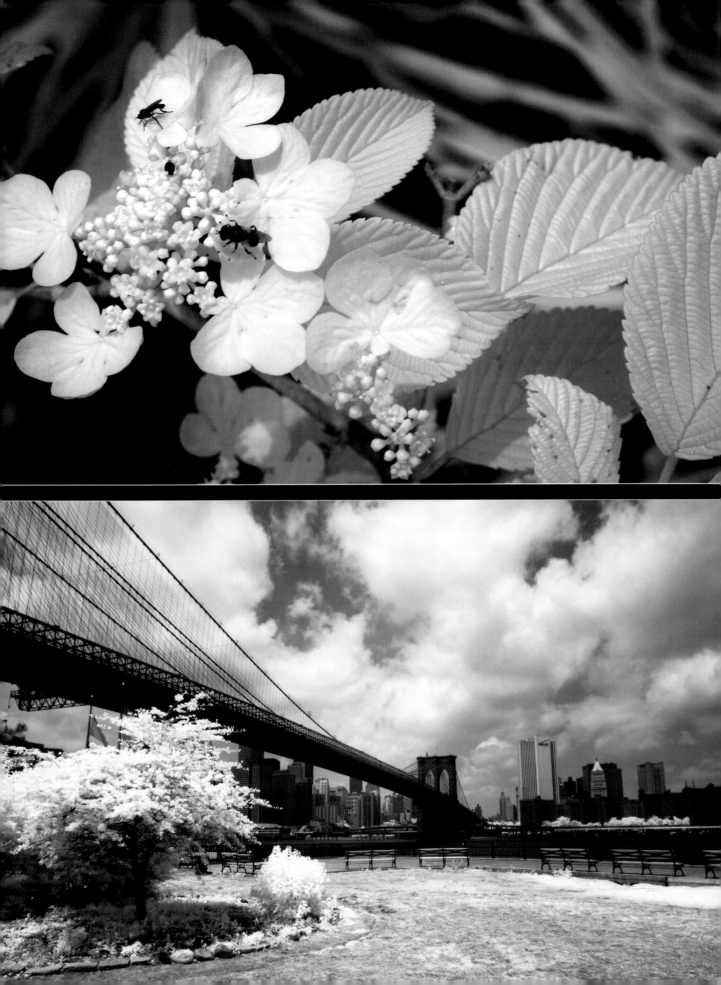

quality. Levels and Curves adjustment is done in Adobe® Photoshop®. Finally, the image mode is changed to Grayscale. The result? Images that look like they were shot on Kodak High-Speed Infrared film with a #87 filter—but without the grain. (David says that while one can convert these images with programs other than Adobe Camera Raw and do all the adjustments in Photoshop, the results are not as good.)

Because lenses focus infrared radiation differently than visible light, focus is always of special concern in infrared photography. Based upon their increased sensitivity (and resultant exposure increase), cameras modified as described above *must* be shot at f8 or higher (David recommends shooting at f11) to

> ▶ **BECAUSE LENSES FOCUS INFRARED RADIATION DIFFERENTLY THAN VISIBLE LIGHT, FOCUS IS ALWAYS OF SPECIAL CONCERN IN INFRARED. . . .**

compensate for the back-focus change resulting from the removal of the low pass and anti-aliasing filters. The increased depth of field at the smaller aperture compensates for the infrared focus shift of the lens.

While photographers have asked whether David can reset the sensor to adjust focus for this phenomena, he says it is not possible, as the amount of adjustment is different for different focal length lenses.

To view David's digital infrared images, go to www.IRDigital.net.

TRANSFORMING COLOR IMAGES TO INFRARED WITH PLUG-INS

If you've shot a scene in color and want to render it as an infrared image, all is not lost. You can use a plug-in to quickly and easily simulate the infrared look.

Plug-ins are small accessory programs that can be installed on your computer to boost the power of your image editing software. Adobe Photoshop features several plug-ins that are loaded during the initial installation. However, because such programs make it easy to apply numerous effects at the push of a button—and allow photographers to build an extensive

library of digital imaging effects—many photographers choose to pick up a number of additional plug-ins.

New plug-ins are manufactured daily. At present, there are at least three plug-ins that can be used to quickly simulate infrared effects: IR Film by Chroma-Software, 55mm by Digital Film Tools, and DI (Digital Infrared Emulation) by Fred Miranda. Each of these quickly applies a set of actions to turn your traditional images into infrared. Overall, the effects are pretty good—but the resulting

images lack some of the subtleties of true infrared. For more information, visit www.chromasoftware.com; www.digital-filmtools.com; or www.fredmiranda.com.

To learn more about the myriad effects you can achieve with plug-ins, see *Plug-ins for Adobe® Photoshop®: A Guide for Photographers* by Jack and Sue Drafahl (Amherst Media 2004).

For another option in transforming a color image into infrared, see pages 113–14.

LENSES AND FILTERS

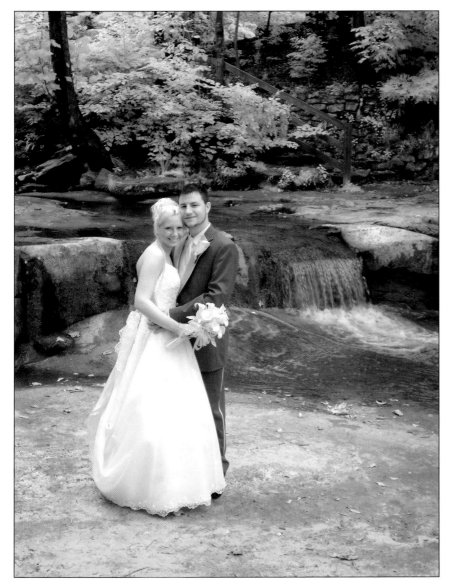

Wide-angle lenses are a favorite for infrared photography. They allow photographers to take in more of the infrared-reflecting elements in the scene. Photograph by Patrick Rice.

LENS SELECTION

The choices of lenses for infrared photography are just as varied as they are for any other film or digital camera application. Most infrared photographers tend to use wide-angle lenses for two important reasons. First, wide-angle lenses include more of the scene that you are photographing and thus capture more elements to reflect infrared light. In outdoor photography, a wide-angle lens will record the grass, trees, and sky, where a longer lens will naturally record less of the scene you are photographing. Second, wide-angle lenses have a greater depth of field range than longer lenses, so the photographer does not have to concern him- or herself with refocusing the camera to ensure the image is sharp.

I routinely use a fisheye lens for infrared imaging. A screw-on fisheye accessory lens is available for the Coolpix cameras. Because the Coolpix cameras have built-in zoom lenses, the fisheye lens becomes a zoom fisheye with a

range from 20mm superwide down to 8mm circle! This creates very dramatic, pleasing images.

This is not to say that normal or even telephoto lenses cannot be effective with infrared photography. I use the entire range of the zoom lens for the Coolpix digital infrared camera and choose a particular focal length setting based on the type of image I am trying to achieve. Since I leave the Coolpix camera in the autofocus mode when creating my infrared images, I simply check the exposure to make sure the f-stop that I am using will sufficiently cover the depth of field.

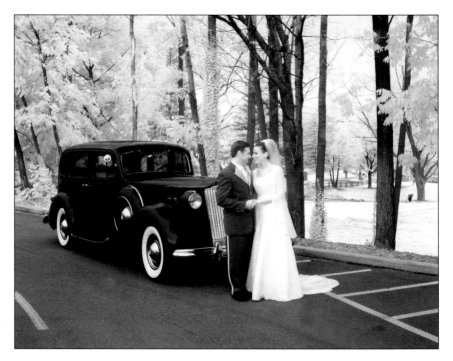

Using a filter on an infrared-sensitive digital camera allows for a more contrasty image with added appeal. The strength of the filter you select will impact your results, allowing for subtle or pronounced infrared effects. Photograph by Patrick Rice.

FILTERS: THE BASICS

The use of filters in infrared photography is of utmost importance. Before we explore the different filters that can be used with infrared, we should first understand how filters work.

Remember that light is made up of differing wavelengths that we see as colors. The blend of these wavelengths gives us our perception of white light. Essentially, a colored filter blocks some wavelengths from the camera while it allows other wavelengths to pass and be recorded on photographic media. The wavelengths of light that are allowed to pass are also referred to

▶ **BOTH INFRARED FILMS AND DIGITAL INFRARED CAMERAS ARE MORE SENSITIVE TO VISIBLE LIGHT THAN THEY ARE TO THE INFRARED SPECTRUM. . . .**

as the light that the filter *transmits.* In normal black & white photography, filters are used in front of the camera lens to change the contrast of the image being recorded. We routinely use yellow, orange, or red filters with black & white imaging to add contrast to the sky for a more dramatic photograph, thereby improving our photographs.

While this same increase in contrast is achieved with filters for infrared photography, the filters' role in producing a strong infrared image is far more significant. Because both infrared films and digital infrared cameras are more sensitive to the blue (visible light) wavelengths than they are to the infrared spectrum, without filtration, the infrared spectrum would be overwhelmed by stronger wavelengths of

You can purchase a wide range of filters in varying strengths—quite inexpensively—in order to produce an image that will appeal to all of your clients, from those who prefer cutting-edge artistry to those who feel more comfortable with something a little closer to black & white. The image on the facing page exhibits much more of an infrared feel than the one pictured below. Photograph by Patrick Rice.

light and would not be as dramatically recorded. In other words, if you do not use a filter to block the transmission of visible light, you will get a flat, low-contrast image that will not truly have the infrared look.

FILTER SELECTION

Which filter to use for infrared photography is a hotly debated subject with photographers. There is no right answer to this question. Photographers use the appropriate filter to get the infrared "look" that they want to achieve. This is a very subjective decision. It is also important to realize that a camera's sensitivity to infrared will greatly influence this decision. The more sensitive the camera is to infrared, the less intense a filter is necessary to achieve an acceptable infrared

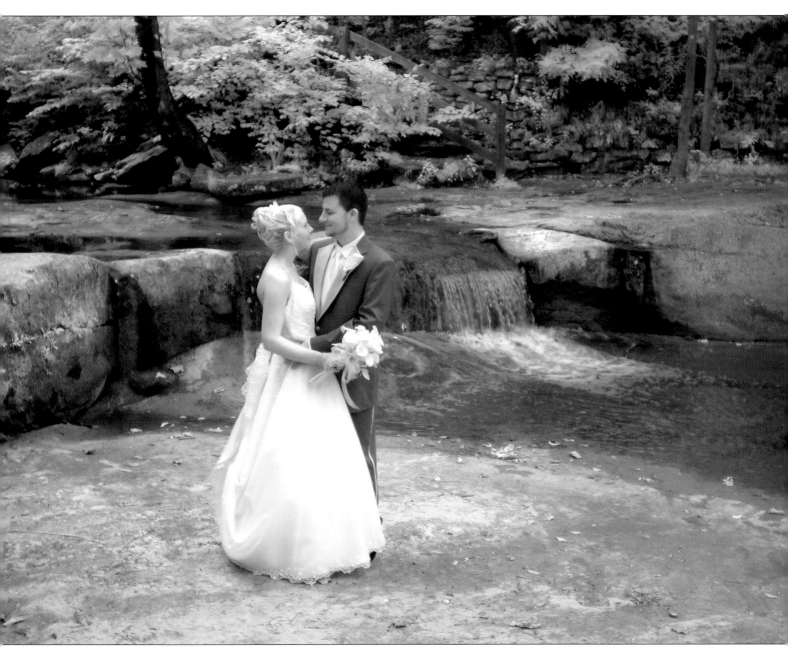

image. I have met many photographers who prefer to use a yellow filter in their infrared photography to give a hint of an infrared "look" without straying too far from traditional black & white photography. On the other hand, I know photographers who insist that opaque filters that block the entire visible spectrum are the only way to produce infrared images.

Using filters that block most or all of the visible light in a scene from being recorded in the camera (for example, #87 or #89 filters or their equivalent; more on this later) usually necessitates using high ISO speeds, large lens openings, and slow shutter speeds. These criteria can present problems. First, as the ISO setting on a digital camera is increased, so is the overall graininess of the image; and while this can be an aesthetically pleasing result in smaller images or in prints made from film, it can be an indication of poor quality in a wall-sized print. Second, as the lens opening is increased, the depth of field or area of acceptable focus is decreased. Finally, as the shutter speed is slowed down, there is more chance for subject movement. Because of these issues, many photographers, myself included, use orange, red, or deep-red filters. These filters maintain smaller lens openings and faster shutter speeds at ISO settings that I find more acceptable.

Glass vs. Gel. Filters come in two types: glass and gel. Both come in a variety of strengths and are available from several manufacturers.

I prefer gel types because they are inexpensive, easy to work with, and come in a wide variety of colors. Few, if any, filter manufacturers make glass filters in all of the colors that I may want to use for infrared imaging. While I have used several Kodak Wratten filters, I prefer those made by Lee and feel that they offer the best quality.

You can consult the chart at the right to determine the necessary increase in exposure for any filter placed on the camera lens. Note that, in each column, the filter factor is listed on the left and the recommended exposure compensation is given on the right.

FILTERING FOR IMPROVED RESULTS

As discussed in the previous chapter, infrared-sensitive cameras are not equipped with an effective infrared-blocking filter and thus record both visible *and* infrared light. In order to ensure the best possible infrared image, you must block visible light from being recorded. An infrared pass filter, made in a variety of strengths and available from a variety of manufacturers, is a must in order to produce a good infrared image. A few such filters are discussed below.

When selecting a filter, keep in mind that results will vary from camera to camera based on the camera model's sensitivity to infrared light. The effects of any given filter on a modified camera will be significant-

EXPOSURE COMPENSATION

FILTER FACTOR	EXP. INCREASE
1.25	$+\frac{1}{3}$
1.5	$+\frac{2}{3}$
2	$+1$
2.5	$+1\frac{1}{3}$
3	$+1\frac{2}{3}$
4	$+2$
5	$+2\frac{1}{3}$
6	$+2\frac{2}{3}$
8	$+3$
10	$+3\frac{1}{3}$
12	$+3\frac{2}{3}$
40	$+5\frac{1}{3}$
100	$+6\frac{2}{3}$
1000	$+10$

Once you know the filter factor for your chosen filter (left column), you can easily determine the recommended exposure increase (right column) to ensure the best-possible results. Note that each time a filter factor is doubled, the exposure must be increased one stop. For instance, a filter factor of 2 requires a one-stop increase and a filter factor of 4 requires a two-stop exposure increase. Use this rule of thumb when determining the recommended exposure compensation for filter factors not listed in this chart.

ly different than that achieved when the same filter is used on an unmodified camera.

#16. The yellow-orange #16 filter blocks light below 510nm, meaning that images produced with it in place will exhibit only a mild infrared look.

#21. This filter blocks light below 540nm, meaning that the shorter wavelengths of light are reflected by the filter and will not be recorded in the image. With these filters in place, the infrared look is still subtle. Images created with this filter are closer to panchromatic black & white in appearance but with a little "snap." To create a filter that fits my camera's 28mm threaded ring, I sandwiched gel filter material that I cut from a filter color swatch pack behind my UV filter, then simply attached the filter combination to the lens. Color swatch packs are available, free of charge, at many photographic conventions and at camera stores.

#25. This red filter is used with traditional black & white photography to enhance contrast. It blocks light below 600nm. Though it is stronger than the #16 or #21, the #25 filter is not strong enough to produce a dramatic infrared look on an unmodified camera. Note, too, that red objects in a scene that are similar in tone to the red filter sometimes appear white in the final image.

Hoya R72. This filter is favored by many photographers for its low cost and ability to block light below 720nm. The filter is very dark and

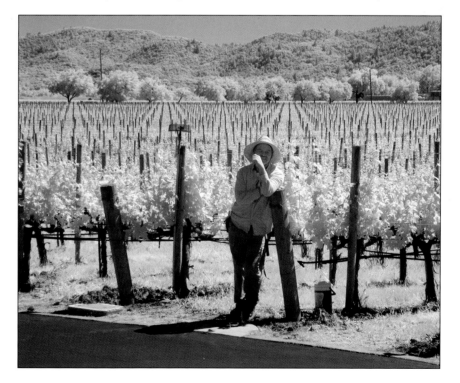

A given filter produces a stronger infrared look when placed on a modified camera than when used on an unmodified model. Photograph by Patrick Rice.

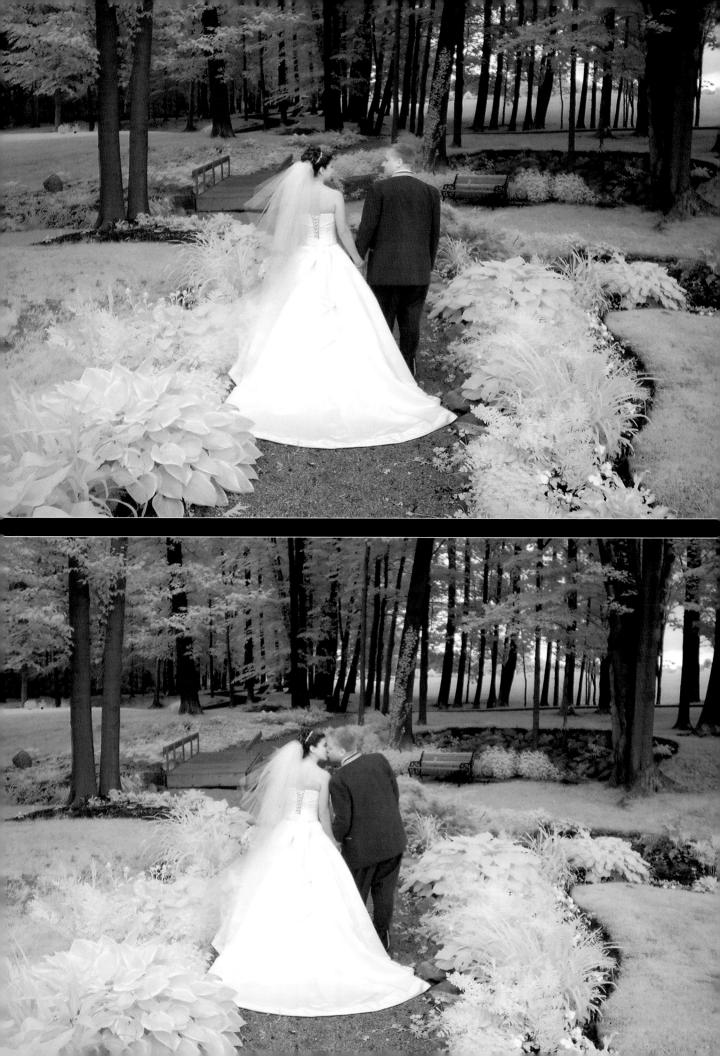

Nikon Coolpix models have a 28mm threaded ring on the front of the camera's zoom lens. Since there are no appropriate filters available in the 28mm size, I purchased a 28–37mm step-up ring from CKCPower.com, along with a 37–49mm step-up ring (very common—you can buy these at any camera store), and then attached a 49mm #25 red filter to it. Unfortunately, I achieved only adequate results. The images I recorded with the digital camera just did not have the same "snap" that I was accustomed to with Kodak infrared film.

The next logical step was to use a filter that blocked more of the visible spectrum and was more responsive in the infrared range. The #87 opaque filter only passes light from about 800nm to over 1000nm. Therefore, only the near-infrared spectrum is recorded by the camera. I used a 49mm #87 glass filter on my step-up ring configuration. The results rivaled that of Kodak infrared film! This was exciting and has changed my entire outlook on digital infrared photography.

Since the #87 filter will fit on all of my Nikon adapter lenses, I can use the Nikon fisheye lens, wide-angle lens, and telephoto lens attachments for infrared imaging. The creative possibilities are endless!

Using step-up rings isn't the only viable option for creating custom-sized infrared pass filters for your digital camera. I recently purchased a 28mm UV filter from CKCPower.com, then cut a circular piece of a #87 Kodak Wratten filter square and inserted it into the lip of the UV filter. The two filters are sandwiched, not to produce a specific effect on the image, but because the UV filter holds the Wratten material in place. Alternatively, some photographers simply tape the preferred filter square in place.

allows very little visible light through. The results produced with this filter are similar to the 89B.

#89B. This filter is the equivalent of the Hoya R72 filter; its qualities are outlined above.

#88A. This filter blocks light below 750nm. It filters more light than the filters discussed less far but is less restrictive than the #87 filters and the Hoya RM90.

#87. This dense filter blocks wavelengths below 800nm, permitting no visible light through. As it is black in appearance, focusing and composing the image through the viewfinder is not possible once the filter is placed on the lens.

Hoya RM90. This filter blocks light that falls below 900nm. Since it filters out so much light, exposure times are on the long side when using this filter.

FILTERING A MODIFIED CAMERA

To enhance the quality of infrared images created with my modified camera (see pages 50–56), I filtered my Nikon Coolpix 990 as I did before the modification was made. However, the images I created with the #87 opaque filter mounted on the lens of my modified camera were almost too extreme for my taste, so I started to experiment with other filters to find one that better suited my needs. I used a #25 red filter and still thought the infrared recording of the scene was too intense, so I chose instead to attach an orange filter in front of the lens.

Whether documenting the romance of the day from behind the scenes or posing the couple, selecting the right filtration will help you to achieve the look you're after. Photographs by Patrick Rice.

(You can decide what infrared "look" is best for your studio and choose a filter accordingly.) With the orange filter in place, the digital infrared images look almost exactly like Kodak High-Speed Infrared film.

Some cameras are differently modified to house a #87 filter inside the camera body. Such cameras require no additional filtration. See pages 50–56 for details.

TECHNICAL TIPS FROM GARY FONG

Imagine taking a photograph looking through a completely black lens, hearing the camera autofocus, and then seeing an infrared image appear on your LCD! Digital infrared is really fun!

The infrared technique used with digital photography is very different than shooting infrared film. With film, you're typically shooting through a yellow or red filter to increase contrast, and using about a 640 ISO, because the red filter knocks out about 2–3 stops.

In digital infrared imaging, an opaque infrared filter blocks out all visible light—so you're basically shooting with the lens cap on! [Gary peeks around the camera to compose the scene using the eye that is not positioned at the viewfinder.] It takes some getting used to (especially the part where the camera actually autofocuses even though you can't see anything!). Once you get good at it, it actually becomes very natural. I normally let the "red dot" (the camera's focusing point) go over the subject I want to photograph—and you can actually frame pretty accurately!

This opaque filter is totally black—you'll really wonder what the heck you did giving this a try! But squeeze the trigger, and look in your LCD screen—and you'll see a striking infrared image! It's so much fun—and the images are breathtakingly beautiful. The best part is, it's true infrared—not an artificial plug-in or special effect.

When using a Nikon 16mm fisheye lens, I cut out a small circle from a sheet of opaque Kodak Wratten gel-filter material (using a quarter for a template), then place this filter material between the rear element and the rear filter. The filter is equally "black."

My Kodak Wratten 3x3-inch color infrared gel filter (which is available on my website for digital photographers, www.digitalphotographers.net) also does color infrared. (Please note, other Wratten gel filters do not work for color infrared, and glass infrared filters don't work, either.)

SETTINGS FOR A TYPICAL OUTDOOR SCENE IN DIRECT SUNLIGHT			
CAMERA	ISO	F-STOP	SHUTTER SPEED
FUJI S1/S2	1600	$^1/_{60}$	2.8
CANON EOS10D	800X2*	$^1/_{30}$	2.8
NIKON D1X/H	3200	20 sec.	2.8

* Equivalent to 1600 ISO.

SHOOTING TECHNIQUES

Shooting infrared poses some unique technical concerns, which will be addressed in this chapter.

COMPOSITION

Opaque filters like the #87 look black and cannot be seen through For this reason, I compose my images using the camera's small viewfinder window and not the larger LCD display, which "sees" through the lens itself. The image in the viewfinder corresponds to the image being recorded, even changing as the lens zooms in and out for different focal lengths.

Other photographers have found it useful to compose the photograph with the camera on a tripod—before the filter is attached. Of course, the filter must be attached without altering the lens focus or the zoom settings, which can be a challenge.

▶ **THE FILTER MUST BE ATTACHED WITHOUT ALTERING THE LENS FOCUS OR THE ZOOM SETTINGS, WHICH CAN BE A CHALLENGE.**

It is a good idea to place your subjects in full sunlight when possible. In inclement weather, you'll need to open up the lens and shoot at a slower shutter speed, and the image will have reduced contrast. Additionally, any foliage in the image will not go as white, and the sky will not be rendered quite so dark in the resulting image.

FOCUSING CONSIDERATIONS

Because the infrared focal point is farther from the camera lens, the lens must be moved slightly farther from the film or sensor to focus an infrared image. This focus difference is most critical when using filters to block all visible radiation.

Many lenses are marked with a small red line or "R" to show you the infrared readjust mark. After you focus the lens on your subject,

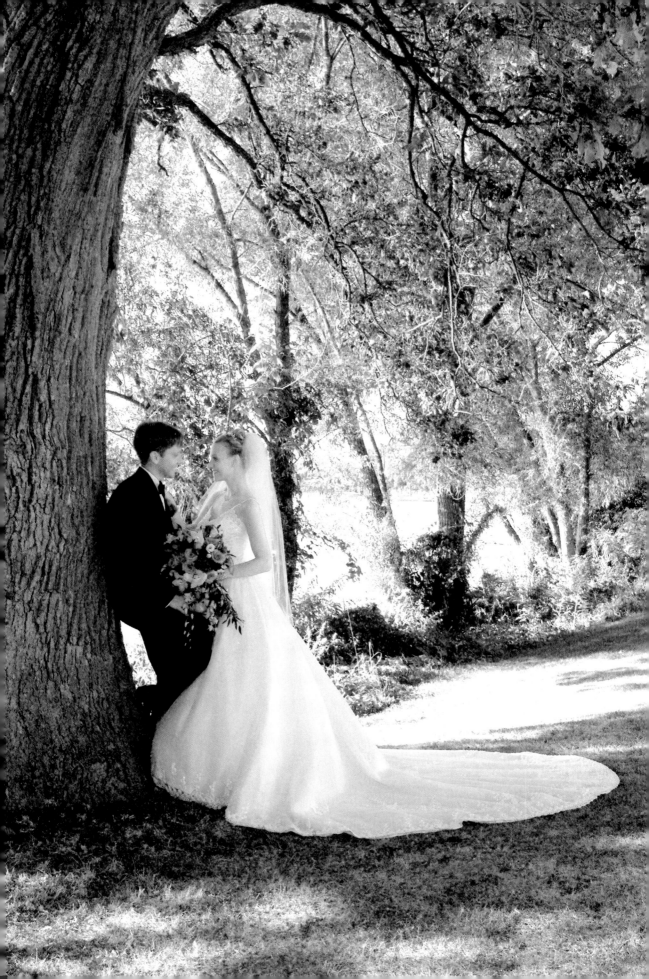

you must move that focus point back to the infrared mark to have the infrared image properly focused on the film.

One way of dealing with the infrared focusing challenge is to shoot at smaller lens openings to increase the effective depth of field. Another technique that helps to maintain sharp images is to use wide-angle lenses. The combination of a wide-angle lens and small lens openings will almost always ensure images that are acceptably sharp.

When I am shooting digital infrared images with my Coolpix camera, I always check to see what f-stop the camera has selected in the

TECHNICAL TIPS FROM DON EMMERICH

Film-based infrared photography has been used for global remote sensing satellites, military reconnaissance, agricultural and forestry crop assessments, and numerous other scientific applications. But professional photographers have also been using infrared capture for creative expression. The look of an infrared image is artistic, yet has a very traditional feel.

Not all digital cameras will allow infrared to pass through to the CCD sensor or CMOS chip. To find out if yours does, point your television remote control at the lens of the camera. While looking through the camera, push any button on the remote. If you see a red light, you're good to go.

There is so much misinformation on digital photography: you need special lights with digital, you can't use soft-focus filters with digital, you can't do this, you can't do that. Shooting digitally is no different than using my Mamiya 645AFD with a film back. I can get realistic infrared shots with my Fujifilm FinePix S1 and S2 Pro, or a Leaf digital back on my Mamiya 645AFD.

You can base exposures for infrared photography on a meter reading, but it's not possible to predict how much infrared the subjects will reflect or emit. With film

capture, getting it right takes knowledgeable estimating or test shooting under specific conditions. And then you don't know the results until you process the film, which must be done in total darkness, without so much as a safe light. What makes digital infrared photography so great is that you can preview your image on the camera's LCD screen, then check the histogram to verify the exposure. Wow! Could it get any easier?

I generally start with an exposure of 1 or 2 seconds, then check the histogram. Objects in a scene with equivalent amounts of white light may not emit equal amounts of infrared. Keep in mind that the shadow areas in a scene will have very little infrared light, even in the daytime. Open the aperture by one stop to avoid underexposure. Infrared radiation does not focus in the same plane as visible radiation, so you have to infrared-focus your camera. The infrared focal point is farther from the camera lens, so the lens must be moved slightly farther from the film or sensor to focus an infrared image. This focus difference is most critical when using filters to block all visible radiation. Most camera lenses have an auxiliary infrared focusing mark. Generally this mark is a red "R" with a red line. Focus

the subject as usual, and then shift the lens distance scale to the "R" mark. Some lenses, particularly apochromatic (APO) designs, may not need focal correction. Consult your camera manual to determine the appropriate use.

For the best definition, use small apertures like f11 or f16 if conditions permit. For people photography, I tend to work at f8 with faster shutter speeds. With scenics it doesn't really matter much. If you must use large apertures, and the lens has no auxiliary infrared focusing, you just have to establish focus settings by trial and error.

My FinePix S2 and my Leaf digital back allow me to capture in black & white mode, but if your camera shoots in color only, you can still use the infrared filter. Open your infrared-filtered color image in Adobe Photoshop and go to Image>Mode>Grayscale to change the RGB image to Grayscale. Go to Image>Adjustments>Levels and move the black point and white point values until it looks good enough to brag about.

Now you know that, with the right digital camera and an infrared filter, you don't have to jump through a lot of computer hoops to reap the brilliant rewards of infrared light.

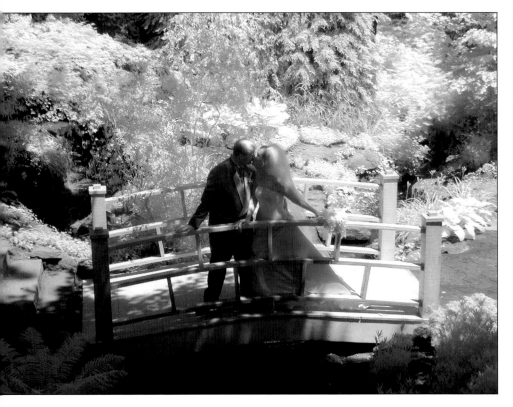

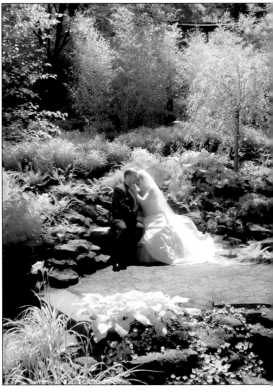

A longer exposure is typical when shooting infrared. Photographs by Travis Hill.

automatic mode. When the f-stops increase to larger openings like f2.8 or f4, I make sure that I am shooting at the widest point on the zoom lens and ensure that I am 20 feet or more away from my subject. When the subject is positioned so that focusing is correct when the lens is set at the infinity focus mark, refocusing for infrared is less of a concern.

Recently, I approached my local camera repair shop, Pro Camera & Video Service in Cleveland, Ohio, to address the infrared focusing situation. After some discussion, the shop technicians determined that they could adjust the focus of the camera internally by using a shim so that the camera would focus the infrared range properly. They were able to perform this modification on two of my Nikon Coolpix 990 digital cameras that they had mod-

▶ **IN MOST CASES, PHOTOGRAPHERS CAN SAFELY USE THEIR CAMERA'S AUTOEXPOSURE MODE WHEN TAKING AN INFRARED IMAGE.**

ified for infrared photography. Since the cameras do not record normally after modification, having the focusing readjusted specifically for infrared made sense. As a result of these modifications, the infrared images made with my Coolpix cameras are usually very sharp at any focal length.

EXPOSURE

In most cases, photographers can safely use their camera's autoexposure mode when taking an infrared image. Since a longer exposure is

typical in infrared imaging, remember to turn off the automatic flash feature before taking your first shot. If the flash should fire during the exposure, you'll degrade the image.

Once the shot has been captured, its exposure should be evaluated on the LCD screen. If the exposure is too dark, note the shutter speed, aperture, and ISO the camera selected (you can check these utilizing your camera's playback mode). Then, switch the camera to the manual mode, and either increase the aperture, decrease the shutter speed, or adjust your ISO. This is something of a trial-and-error venture, as exposure meters used for traditional color and black & white images will not provide accurate readings when used with infrared.

When I shoot in autoexposure mode (which often produces good results!), I analyze each image on my camera's LCD screen, then select the manual mode to retake the shot—with a little exposure compensation. Photographs by Patrick Rice.

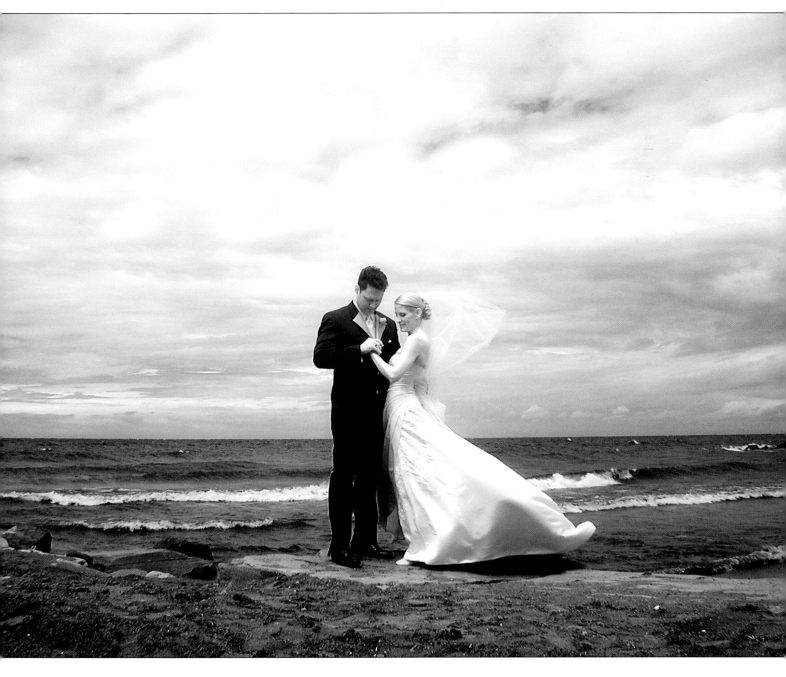

It's important to realize that, depending on the sensitivity of your camera and the strength of the filter on its lens, an infrared exposure can be quite long—even in full sunlight. With the modified Nikon Coolpix cameras, exposures are very similar to using Kodak High-Speed Infrared film. With the Kodak film, I would set the aperture at f11 and bracket exposures from $\frac{1}{60}$, $\frac{1}{125}$, and $\frac{1}{500}$ on a sunny day with a #25 filter. The best exposures were typically $\frac{1}{125}$ or $\frac{1}{250}$, which I recommend as a starting point with a modified Nikon Coolpix camera. Unmodified digital cameras require much longer exposures in bright sun—usually $\frac{1}{4}$, $\frac{1}{2}$, 1, or 2 seconds. The shutter speeds must be even slower in lower-light conditions. Since infrared sensitivity varies from camera to camera and depending on the strength of the filter, you'll need to determine the required filter factor in order to gauge the extent

With an opaque filter on your camera's lens—and the consequent long shutter speed—you'll want to use a tripod. Photograph by Patrick Rice.

to which you should increase your exposure to produce the most desirable results.

Camera Shake. With opaque filters like the #87 filter in place, all images should be taken on a tripod to reduce camera shake. To make an exposure with my Coolpix 990, I place it on a tripod then I either press down on the shutter very gently so I do not create any camera movement, or I use the camera's self-timer. The camera has two different self-timer settings: If you press the shutter button once, the image will be recorded after 10 seconds. However, if you press it twice, you will record the image after only 3 seconds. I choose to use the shorter duration so that my subjects do not have to rigidly hold a pose for 10 seconds or longer.

▶ **WITH OPAQUE FILTERS LIKE THE #87 FILTER IN PLACE, ALL IMAGES SHOULD BE TAKEN ON A TRIPOD TO REDUCE CAMERA SHAKE.**

Necessity is the mother of invention and, fortunately, the designers at www.CKCPower.com created a camera bracket for the Nikon Coolpix 990 digital camera that has incorporated a cable-release mechanism. This bracket does a better job in eliminating camera shake than just mounting the camera on a tripod. With the bracket, I no longer needed to use the self-timer or to attempt to press the shutter without shaking the camera. The bracket threads onto the camera's tripod socket, and has an opening on the bottom of the bracket that allows it to be threaded onto a tripod. I attached a Bogen 3157 quick-

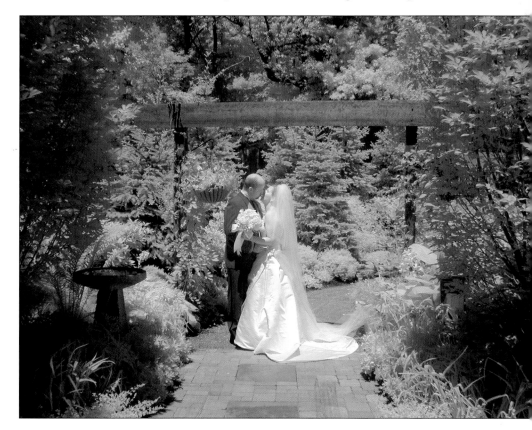

For sharp images at long exposures, eliminating camera shake is critical. Photograph by Travis Hill.

release plate to the bottom of the bracket so I could quickly attach this camera-and-bracket assembly to my Bogen 3265 head on my tripod. The bracket is designed to rotate out of the way without having to be disassembled for the changing of batteries or CompactFlash cards.

I have found there is still some camera shake—especially at longer exposures, so I approached the designers at Custom Brackets Inc. about designing a more suitable camera bracket for the Nikon Coolpix cameras. Their design is far more rigid, and there is no camera shake at any shutter speed.

Shooting in Black & White Mode. Shooting with the camera in its black & white mode is usually desirable because the photographer can better visualize the infrared image via his or her LCD screen. Because we like to show our clients their images on the LCD screen immediately after they are recorded, shooting in the black & white mode is an advantage to them as well. In being able to visualize their photographs on-site, their excitement about the images we are creating for them is maximized.

If your camera does not offer a black & white mode, you can photograph the scene in color and convert it to black & white in Photoshop by going to Image>Adjustments>Desaturate. Another option is

Using your camera's black & white mode will allow you to better visualize the image on the camera's LCD screen. Photograph by Jacob Jakuszeit.

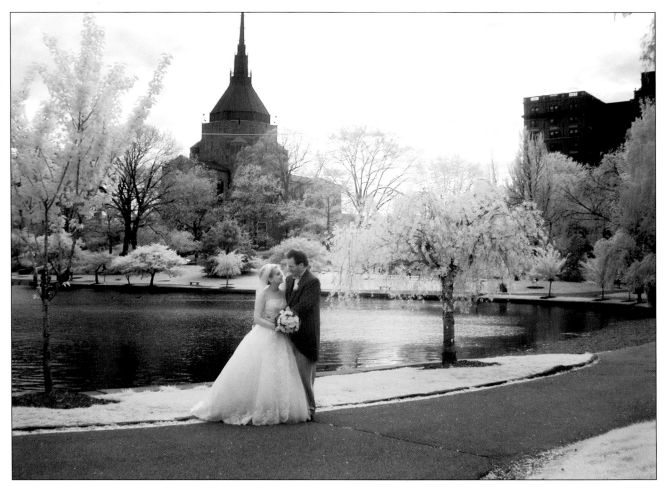

Whether shot in the studio or on location, infrared is becoming increasingly popular with teens and high-school seniors. Photograph by Patrick Rice.

to change the color mode from RGB to Grayscale by going to Image>Mode>Grayscale; however, the former option yields better results.

Keep in mind that in blocking visible light, a filter removes most of the color information from the scene. Therefore, you will not achieve a color infrared image when shooting in the color mode.

Working Indoors. You can create infrared images indoors when there is sufficient illumination to make the exposure. However, a flash may be required to increase your odds of success. For more information, please see chapter 7.

Shooting indoors, especially with a filtered camera, will require a significantly longer exposure. As with any longer exposure, be sure to mount your camera on a tripod. To further ensure that your image is free from the effects of camera shake, you can also use a cable release or the self-timer feature if your camera offers this option.

As when shooting outdoors, any live plants in the scene will be rendered light gray or white, and clothing will still reflect light in varying degree depending on the fabric from which the garments are made. (For more information on how infrared "sees," see chapter 8.)

Pseudo Color Infrared. About two years ago, my stepson Travis Hill was taking digital infrared images during a wedding that he was photographing with me. On the Nikon Coolpix digital camera, the

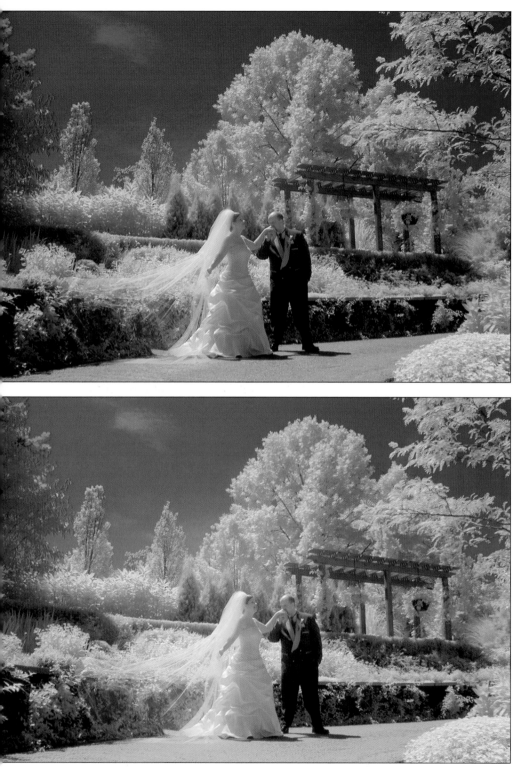

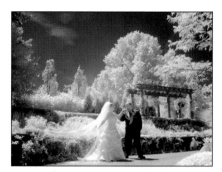

Travis Hill created the color images on the left with his camera set in the automatic mode, while the image above was captured in the manual mode. You'll note that the top color image lacks clean white tones and is a bit dark. To address these issues, a Levels adjustment was made in Photoshop.

black & white mode is only accessible when you turn the switch to the "M" (manual) position on the top of the camera. Travis inadvertently moved the switch back to the "A" (auto) mode and continued to take photographs. To his amazement, he recorded a very striking pseudo color-infrared image. He showed me the photograph on the back of the screen, and it didn't immediately register with me as to what he

had done. My first thought was that maybe something was wrong with the camera.

Once I realized what had happened, I instructed Travis to move the camera back to the "M" setting for black & white infrared photography. He hesitated, insisting that this color image was "really cool." I just told him it looked weird and to switch the camera.

It should be noted that this incident unfolded only a few yards from a puzzled bride and groom. They came over to ask what the debate was about, and Travis showed them the "color infrared" image from the last pose. The bride and groom absolutely loved it! They insisted that it not be deleted and asked Travis to create digital infrared images in both black & white as well as in color. The couple couldn't wait to see these unique photos among their wedding proofs, and they ordered several of these color images.

▶ THE PSEUDO COLOR-INFRARED IMAGES THAT WE RECORD FOR WEDDING CLIENTS GIVES IMAGES A STRANGE BUT PREDICTABLE COLOR CAST.

I call this "pseudo color-infrared" because it is not at all like true color infrared imaging that is created on film. True color infrared film is made by Kodak as a slide film. Until a few years ago, it was processed in the obscure E4 chemistry. Then Kodak reformulated the film so that it could be processed in the more common E6 chemistry. When shooting color infrared slide film, the photographer usually uses a yellow filter in front of the camera lens. Blue skies will photograph a dark blue or gray color, and foliage will record in red or magenta.

The pseudo color-infrared images that we now routinely record for wedding clients gives images a strange but predictable color cast. Just like with our digital black & white infrared photography with the Coolpix camera, we leave a #25 red filter on the camera lens. In the color mode, the areas that reflect the infrared light are recorded in a cyan tone while the areas that might absorb infrared record in a magenta tone. The contrast between white clouds and a normal blue sky is indeed striking.

Though experimentation, we have found that using Auto Levels in Photoshop gives a very nice and subtle representation of the image. The clouds in the sky go back to white, as does the bride's wedding gown, while the grass and trees are registered in cyan or are almost blue-green in appearance. If the groom's tuxedo is wool or cotton, it records as black in the image; however, any synthetic material is rendered cyan in appearance.

We have found this pseudo color-infrared imaging very useful for landscape photography. The contrast is incredible (as it is in all

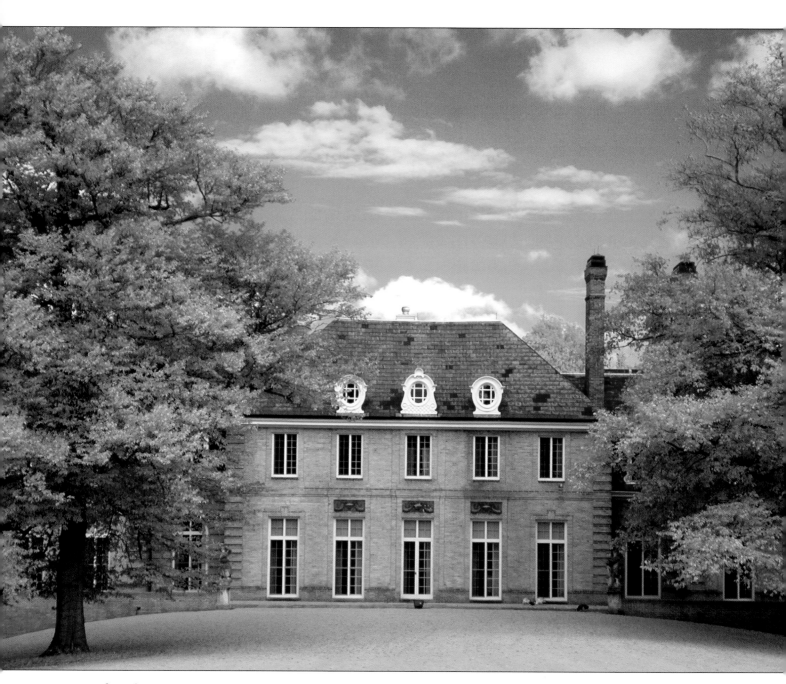

infrared imaging), but it's the color that truly creates a singular, striking appearance. It is a sort of "pop art" infrared imaging—something Andy Warhol might have appreciated. For me personally, the landscapes better match our room décor than a straight black & white infrared image would. I will certainly admit that this use of digital infrared imaging is an acquired taste. It is certainly not for the mainstream population—but I have always enjoyed being a little different.

Night Photography. Infrared photography at night resembles traditional black & white photography at night, except that bright light sources like streetlights take on the ethereal glow (also known as halation; see page 32–33) that is typically produced with Kodak infrared

Here's another look at the difference between black & white and pseudo color infrared. Photographs by Patrick Rice.

film. The camera must be on a tripod, and exposures of f4 with shutter speeds ranging from 1 to 4 seconds are typical.

When using flash, it is important to remember that either the lens or the light source should be filtered (unless you're using a modified camera that *contains* a filter). Also, a flash or other light source that is filtered with an opaque filter (#87 or #89) will illuminate a subject even though it doesn't appear to give off light. For this reason, many companies have installed

▶ **THE CAMERA MUST BE ON A TRIPOD, AND EXPOSURES OF F4 WITH SHUTTER SPEEDS RANGING FROM 1 TO 4 SECONDS ARE TYPICAL.**

infrared-sensitive surveillance cameras and infrared-filtered flash units that automatically fire and record images when a sensor is tripped. Because infrared light is not visible, a burglar would never know their picture was taken because the eye would not see the flash—even though the infrared film would record it.

Flash usage is covered in more detail in the following chapter.

FUJI S2 DIGITAL CAMERAS

Two top photographers and instructors, Don Emmerich and Gary Fong, create digital infrared images with unmodified Fuji S2 digital cameras. These photographers and others are using mostly opaque filters to record the infrared range. The images that they produce are quite stunning. The only drawback to creating digital infrared with this camera and others is the very long shutter speeds necessary to record a proper exposure. For nature and scenic photography, this is a nonissue. It doesn't really matter how long the exposure is if there is no subject to move in the image. However, for people photography, this can present a major challenge. For example, many wedding photographers try in vain to get the bride and groom to hold still during an exposure of 1 to 3 seconds (which is typical). Many of the final images look acceptably sharp at small sizes but show subject movement in larger prints. We sell numerous 8x10-inch infrared images to each of our wedding clients. In addition, 75 percent of these clients purchase 16 x 20 or 20 x 24-inch digital infrared wall prints. In these larger images, any subject movement would be unacceptable.

TROUBLESHOOTING TIPS FOR DIGITAL INFRARED IMAGING

Below is a review of some of the most pervasive problems in digital infrared imaging, along with some advice on preventative measures that can be taken to improve your photos.

BLURRY IMAGES

To ensure the very best image, take extra care to ensure a sharply focused image when shooting in low light. The lower the existing light level (overcast, heavy cloud cover, etc.), the longer the exposure and more apt the image is to suffer from the blurring effects of camera shake. For the best results, lock in the center focus point or the image will focus beyond your subjects. Once you lock focus, you can recompose your photo as necessary.

If you used your camera's autoexposure mode to capture the image and are unsure whether a slow sutter speed–camera shake combination was the root of your trouble, just use your camera's playback mode and check to see which shutter speed was selected by the camera. If your shutter speed was too long, you probably experienced camera shake. To remedy the situation when shooting a similar image, try a weaker filter (a #21 orange instead of a #25 red, for instance). Remember, though, that your images will exhibit less of an infrared effect when you use a weaker filter.

ENHANCING CONTRAST

When examining your images in Photoshop, you'll often find that a particular photo could be improved by enhancing its contrast. It is normal to need to adjust the Levels of the dynamic range of an image. In photos where the subject is comprised largely of light or dark tones, the center-weighted meter may recommend over- or underexposure. In photographing weddings, for instance, the center-weighted metering of the camera reads the white reflectance of the bride's gown and gives the image half to a full stop less light than it may need.

To ensure a more dynamic range of tones from black to white, first access the image histogram by going to Image>Adjustments>Levels. Then move the right-hand, delta-shaped "handle" on the input scale to where the histogram begins to show information; you will brighten up the image and make the whites cleaner. You will probably also have to move the left-hand slider on the Levels scale to adjust the black point so that the blacks in the image (groom's tuxedo) are richer looking. This quick Levels adjustment is usually all that is needed to achieve dynamic digital infrared photographs. We have also saved time by running all digital infrared images through Auto Levels; to accomplish this in the most efficient manner possible, we use the automated batch process in Photoshop (File>Automate>Batch).

NOISE AND GRAIN

When I was using my Nikon 950 Coolpix camera, we made many large digital infrared photographs (up to 20 x 24 inches in size), despite the camera's small file size. Unfortunately, when the file was enlarged, pixelization occurred. To combat this problem, we added noise in Photoshop. This added "texture" masked the pixelization and simulated the look of the heavily grained Kodak High-Speed Infrared film.

The Coolpix 990 has a larger file size than the 950 and can produce better-quality enlargements than the 950; therefore, we tend to add less noise to these images.

It is a good idea to add noise to images that will be printed larger than 16 x 20 inches. In Photoshop, simply go to Filters>Noise>Add Noise. Inside this menu, enter a number (say, 5 pixels) in the Amount field, and choose the Gaussian option under Distribution. Also, when working with a black & white infrared image, be sure that the box next to Monochromatic is checked.

For 8 x 10-inch images, we usually added 5 points of noise. For 11 x 14-inch images we sometimes added 5 points twice. We've found that adding noise in smaller amounts, two or three times, looks better than adding a lot of noise all at once. Each image is different, so you'll need to look at the preview button in Photoshop and add noise until the image looks good to you.

Adding grain to your image will achieve a slightly different effect but may be a good choice depending on the image. To add grain, go to Filter>Artistic>Film Grain, then adjust the Grain, Highlight, and Intensity sliders to get the look you want.

Adjusting the shadow and higlight sliders in Levels will improve the contrast in your digital images. Photographs by Barbabra Rice.

INFRARED AND FLASH

When shooting infrared indoors or on location when the light level is low, using flash will enhance your results. This chapter provides the basic information you need to get started.

THE BASICS

All flash units, both studio lighting and portable flashguns, emit light in both the visible spectrum as well as the near-infrared spectrum. Therefore, flash photography is indeed possible with all infrared imaging. I have been creating infrared flash photographs for many years with a great deal of success by utilizing a very simple and specific method of exposure—whether the infrared image is being created with infrared film or digitally.

With the Nikon Coolpix cameras, you can use the camera's built-in flash, but there are some limitations. As with the built-in flash units on any camera, red-eye can be a problem. To prevent this problem, make sure that the subject is looking slightly off-camera. While red-eye is never a positive feature in a portrait, the effect is especially spooky in infrared, because the red filter in front of the lens turns the red-eye white.

▶ **ALL FLASH UNITS EMIT LIGHT IN BOTH THE VISIBLE SPECTRUM AS WELL AS THE NEAR-INFRARED SPECTRUM.**

If you prefer, you can attach a Nikon flashgun to the camera. When using a Nikon accessory flash unit, simply put the Coolpix camera in the full manual mode and set the f-stop and shutter speeds to correspond with the distance on the Nikon flash. Next, open up the aperture by one f-stop.

In the studio, we use our Profoto Compact 600 flash unit or a Metz 45CT1 portable strobe for all of our photography. With my Nikon Coolpix camera and a #25 filter indoors, I found that the autoexposure mode consistently produced an image that was about one stop

underexposed. To remedy the situation, I kept the camera set to ISO 100 but opened up one stop from the normal flash meter reading. I consulted the camera's histogram to ensure a correct exposure. This method always gave me perfect exposures for my infrared images with flash.

Using a built-in flash in color photography can result in red-eye. The same problem is an issue in infrared—as is apparent in the image on the left—though the effect is a bit different. While infrared flash bulbs (above) are no longer commercially available, you may be able to track some down on the Internet. Photographs by Patrick Rice.

INFRARED FLASH

At one time, infrared flash bulbs were commercially available to use with cameras. I managed to acquire a set of these infrared bulbs made by the General Electric Company. The Synchro-Press #5R blackout bulbs featured a thin filament that only required half as much current as conventional flash bulbs to fire; an extra-sensitive primer for accuracy in firing; a one-piece aluminum base shell for superior electrical contact; and bent leads to reduce bulb blackening and increase output. General Electric produced these specialized flash bulbs to be used with cameras loaded with infrared film without the presence of visible radiation.

"Standard" flash emits wavelengths of light that fall into both the visible light spectrum and the infrared spectrum. If you are using a flash to provide the light necessary to expose an infrared image, you can either filter the flash *or* the camera. For instance, if you place a #87 filter in front of your lens,

▶ **STANDARD FLASH EMITS WAVELENGTHS OF LIGHT THAT FALL INTO BOTH THE VISIBLE LIGHT SPECTRUM AND THE INFRARED SPECTRUM.**

your camera will not record visible light. Alternatively, filtering the flash unit would block the transmission of the visible light wavelengths, so there would be no visible light given off. (Note that, since no visible light is given off, you will not *see* your flash fire, though your subject will be washed in infrared light!) Both options will produce a similar image.

When using flash, be sure to select the manual setting. In the automatic mode, the sensor detects visible light and, without it, it cannot gauge how much light to emit.

I usually shoot unfiltered flash exposures with a #25 filter on my lens. Through experimenting with infrared and flash, I have found that it is usually necessary to open up one stop on the camera because the ratio of visible light to infrared light being emitted is usually 2 to 1.

HOW INFRARED SEES

Whether you're shooting weddings or portraits, architecture, or landscapes, learning how infrared light will render your subject will give you an important advantage in planning your session. In this chapter, you'll learn how the most frequently photographed elements of any photographic scene—from clothing, to hair color, to metal objects, to foliage, and even water—will appear in the final image.

SKIN TONES

Skin tones can photograph in a very different and pleasing manner with infrared photography. As a general rule, skin pigment tends to lighten with infrared imaging, creating a softer overall appearance. As

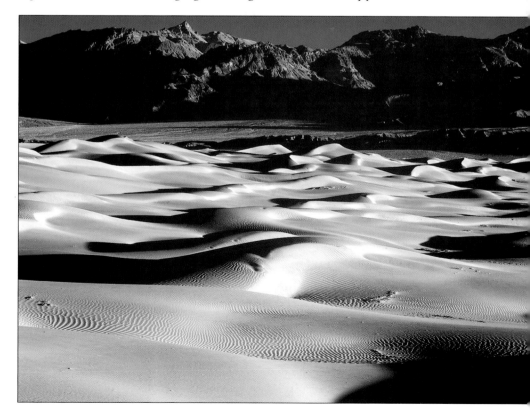

Learning how infrared light will render your subject will give you an important advantage in capturing the average—or extraordinary—scene to its best advantage. Photograph by Don Spangler.

can be seen in the following paragraphs, the medium's "tolerance" for a wide variety of skin problems is another benefit of using infrared imaging.

When photographing teens and high school seniors, infrared can greatly enhance the complexion, since acne and other skin blemishes are greatly diminished or eliminated altogether—without any digital enhancement or artwork. Some seniors have commented that their skin has never looked so good.

Another thing to keep in mind is that suntans and sunburns do not record in infrared. Moreover, tan lines are hidden. Infrared can allow

Gorgeous skin tones are just one of infrared's advantages—and one that may help to account for its growing popularity amongst teens and seniors. Photographs by Patrick Rice.

you to keep a portrait session that would have to be canceled due to these skin coloration problems.

Infrared imaging also softens age lines and gives the skin a healthier and more youthful look. I have had clients compare the beautiful skin quality portrayed with infrared to the Hollywood glamour photography of the 1930s and 1940s. There is a timeless quality to infrared portraiture.

Tattoos. Tattoos can be a great subject for infrared photographers. Unlike suntans or sunburns, the ink that is used to color the skin penetrates very deeply and records in stark contrast to the surrounding skin, which appears lighter than normal. The only exception to this is that some red tones in the tattoo may be canceled out by the red filter in front of your camera. Reds that fall in the same wavelength as your filter will appear white. (Likewise,

> ▶ **I HAVE HAD CLIENTS COMPARE THE BEAUTIFUL SKIN QUALITY PORTRAYED WITH INFRARED TO HOLLYWOOD GLAMOUR PHOTOGRAPHY. . . .**

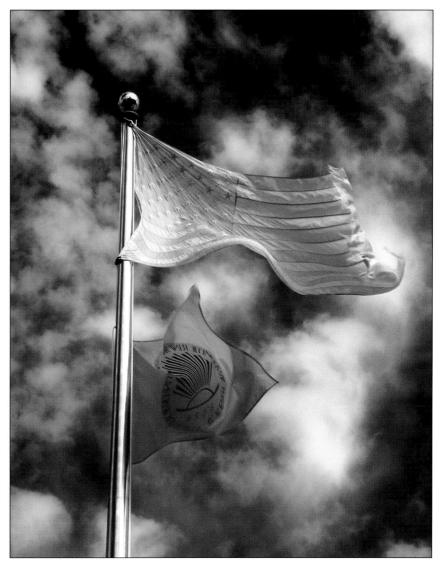

When photographing a red object with a red filter on your lens, you may experience some surprising results. Photograph by Patrick Rice.

when using a #25 filter and photographing the U.S. flag, the red and white stripes of Old Glory may appear to pale!)

Piercings. Piercings on a person's body will also have a very strong contrast with the skin tones, which will appear lighter with infrared. (For more information on the photography of metal objects, see pages 94–95.)

EYES

Eyes can be very interesting in infrared. Some eyes photograph very well with infrared, while others can be quite disturbing. Whenever you are going to photograph a subject close-up in infrared with him or her looking back at the camera, take a test exposure and use the camera's zoom function to achieve a closer inspection of the eyes. In addition to zooming in on the eyes with the camera, I also look at the image on

Deep-blue eyes, like deep-blue skies, tend to be very dark and even black in infrared. Eyes without a hint of eye color are somewhat disturbing and even ghostly. It's a good rule of thumb to have your subject look slightly above the camera. As is clear in the image on the left, infrared can see through many a disguise—at least as far as sunglasses are concerned. Photographs by Barbara Rice.

the LCD screen with my 2x loupe to further enlarge the image. If the eyes look pleasing after making these checks yourself, go ahead and continue as you would for normal photography. However, if the eyes look strange, you may choose to have the client look off to one side or down in the frame. I have found that deep-blue eyes, like deep-blue skies, tend to be very dark and even black. Eyes without a hint of eye color are somewhat disturbing and even ghostly—not usually the look I am trying to achieve. It is a good rule of thumb to have your subject look slightly above the camera. In the image the subject will still seem

to be looking at the camera, but you will be able to keep the definition in the eyes with infrared.

HAIR COLOR

Hair color can be quite revealing with infrared imaging. My stepson, Travis Hill, and I were teaching a class on infrared wedding photography one day and discovered this firsthand. Our model, a beautiful girl in her early twenties, had gorgeous blond hair. We took photographs in color, traditional panchromatic black & white, and black & white infrared. After we had the images printed, we noticed that something seemed odd. When we compared the panchromatic black & white images with the black & white infrared images, the hair was completely different. On the traditional black & white images, her blond hair recorded a very light gray. However, with the black & white infrared images, her hair was very dark gray. After I pondered the difference for a while, I decided to test a theory. I called the model and asked her what her "real" hair color was. The girl was stunned by the question but shyly admitted that she colors her hair blond. Taking my theory a step further, I noticed that older individuals sometimes dye their hair back to the dark color it was when they were younger to hide the natural graying of their hair. In infrared imaging, gray hair that is dyed darker will record a very light gray. The verdict is, infrared imaging can "see" a subject's true hair color. (I only wish that I had had this revelation back when there was popular debate as to whether then President Ronald Reagan dyed his hair to maintain its jet-black, youthful appearance. I am sure an infrared image that proved he dyed his hair could have brought a sizable paycheck from one of the tabloid newspapers!)

▶ **WHEN WE COMPARED BLACK & WHITE PHOTOS WITH THE BLACK & WHITE INFRARED IMAGES, THE HAIR WAS COMPLETELY DIFFERENT. . . .**

MAKEUP

Makeup can be used very effectively when photographing a subject in infrared. You can add dimension to the cheekbones and definition to the lips and eyes with the proper choice of makeup colors. Be sure to avoid medium-red colors if you have a red filter in front of your digital infrared camera. The filter may cancel out the makeup color.

FABRICS

Infrared imaging does not always see fabrics and clothing in ways that we might expect. Through my observations of the infrared images I've taken through the years, I have discovered a few characteristics of how infrared records fabrics. Natural materials like cotton and wool tend to

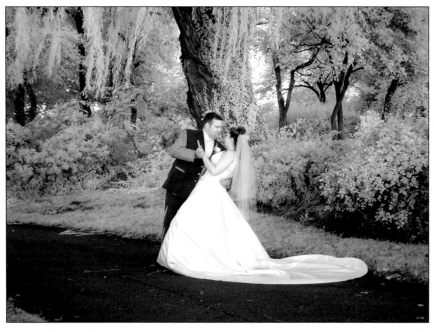

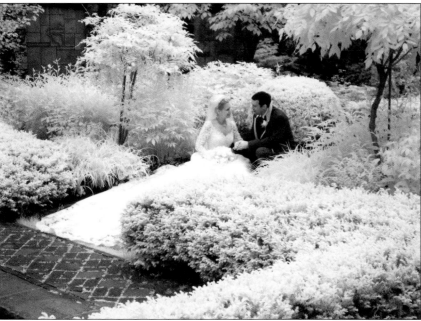

Shooting in infrared, you quickly realize that there's a difference in the way natural versus man-made fabrics are recorded. Top left photograph by Patrick Rice. Bottom left photo by Tony Zimcosky. Above image by Richard Frumkin.

photograph in the shade in which they are dyed. For instance, if the groom's black tuxedo is made of a quality wool fabric, it will record black in an infrared image. However, many tuxedos are made from polyester or other man-made materials. These fabrics tend to reflect infrared radiation and record in a shade of gray or even white in infrared. This is especially noticeable when the tuxedo has man-made satin trim on the lapel and/or piping on the trouser legs. This tendency of infrared is especially interesting when not all of the tuxedos worn by the men in the wedding party record the same way. Some may be black, some medium-gray, some even near-white in color. (We feel that this "discrepancy" adds a certain charm, but we correct it in

Very white or light foliage is the hallmark of much infrared photography. Photographs by Don Spangler.

Photoshop if the couple prefers.) The bride's white dress always records white in black & white infrared.

Understanding how fabrics will photograph in infrared can be a tremendous advantage for photographers. Having the clothing lighten in appearance can help to bring more attention to the subject by helping them to stand out from the background. This difference can change the entire key of an image from low key to high key and may thus change the overall feeling of the photograph.

FOLIAGE AND INFRARED

When we think of a typical infrared photograph, we usually think about how the trees and grass are rendered a very light gray or even white. This dreamlike, snowy appearance is one of the most aesthetically pleasing reasons for infrared imaging.

Most plant life contains a substance called chlorophyll. In a healthy plant, chlorophyll absorbs visible light, but reflects any infrared light striking it. This reflection of the infrared light is the reason behind the

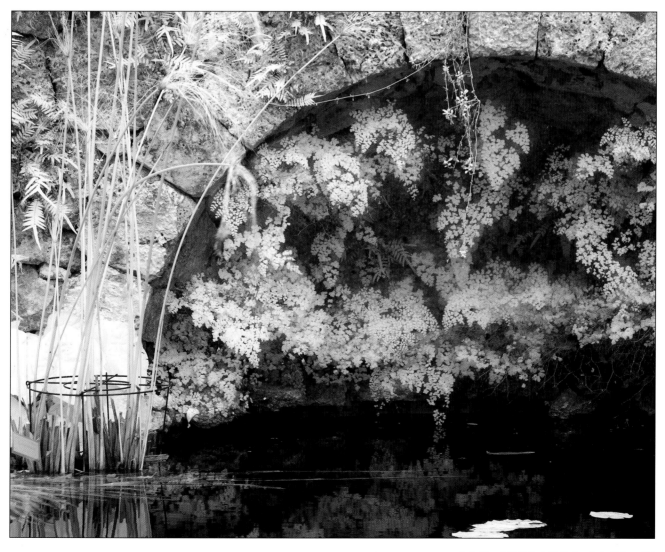

almost white appearance of leaves and grass. Earlier in the book, in a discussion on the military's application of infrared imaging, you learned that when plant life is severed from its root system, the chlorophyll diminishes, and the plant no longer reflects infrared light (and no longer appears white in an infrared image). In one of the outdoor photography sets that we use for portraits, we have a substantial number of artificial (silk) plants.

▶ **THE COLOR GREEN IN AND OF ITSELF DOES NOT PHOTOGRAPH LIGHT GRAY IN INFRARED; IT RECORDS DARK GRAY.**

This allows us to ensure that our set looks the same twelve months a year. While the greenery makes a convincing backdrop in our color and panchromatic black & white images, all infrared images of this set show these plants as dark-gray in color—not white. This proves that the color green in and of itself does not photograph light gray in infrared; it records dark gray.

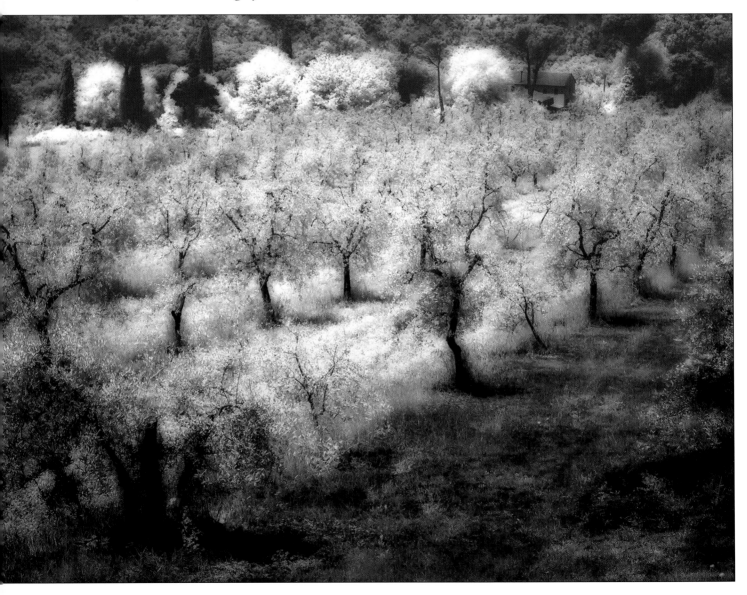

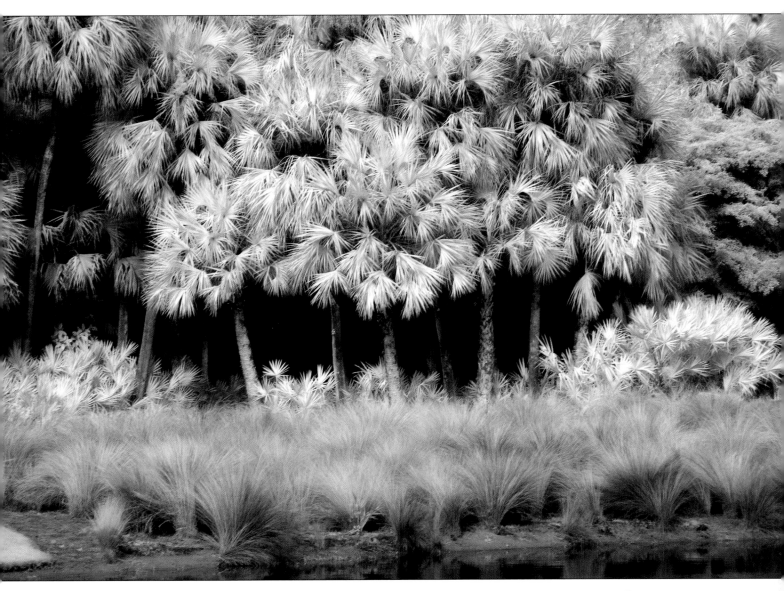

The white or light coloration of foliage can be the beginnings of a beautifully contrasty scene. Photographs above and on facing page by Barbara J. Ellison.

Broad-leaf plants contain more chlorophyll and reflect more infrared light than other varieties. This is why palm leaves and cacti are some of my favorite plants to record in infrared. Needle-like foliage reflects less infrared light because it contains much less chlorophyll.

Plant life in general reflects infrared light in differing amounts depending upon how much it is being illuminated by the sun. Grass and broad-leaf foliage that are drenched in sunshine usually record snowy white in infrared. However, grass and foliage that are in the shade in that same scene will record in tones of medium to dark gray in infrared. On a cloudy day, the grass and broad-leaf foliage will record light to medium gray because there is less infrared light in the atmosphere being reflected upon them. Infrared exposures, like traditional black & white or color exposures, must be longer on a cloudy day.

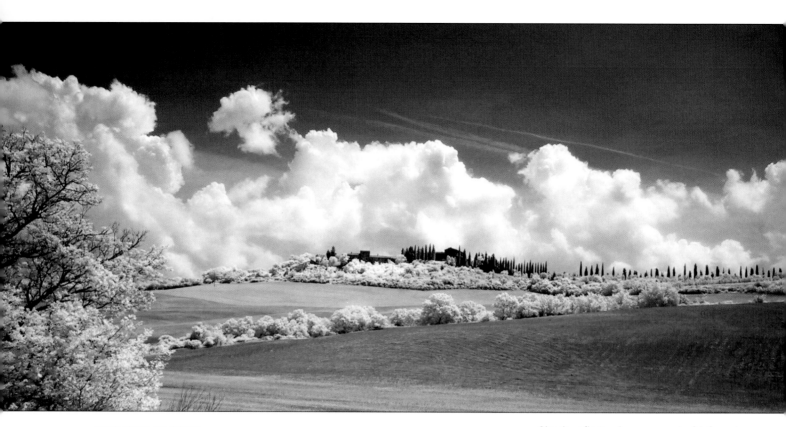

SKY AND CLOUDS

Some of the most dramatic uses of infrared imaging are in photographs of clouds and blue skies. When you take a photograph of the sky while facing the sun with any film or digital camera, the sky has little if any color and appears white. If you photograph away from the sun (the sun at your back) on a bright day, you get a much bluer and richer sky with color imaging. In black & white photography, you will record a medium-gray sky when shooting with the sun at your back. With infrared, however, you can get very dark or even black skies.

Clouds reflect most of the infrared light in a scene and record snowy white in many images. The combination of the black skies and white clouds make for very dramatic images with infrared. Without the presence of clouds in the sky, infrared imaging gives the appearance of moonlight. In the 1930s, Hollywood producers used this to their advantage when shooting movies. Remember, this was a time when color film hadn't quite been perfected, and almost all movies were filmed in black & white. Movie companies quickly learned that it was cheaper to shoot infrared film to create the illusion of nighttime than it was to actually illuminate a scene for a night shot. Very few people in the audience would be able to determine that these night scenes were actually filmed in the mid-

Clouds reflect a large amount of infrared light and therefore, on sunny days, record snowy white. Photograph by Barbara J. Ellison.

> ▶ **THE COMBINATION OF THE BLACK SKIES AND WHITE CLOUDS MAKE FOR VERY DRAMATIC IMAGES WITH INFRARED.**

dle of the day. The only clue that would give away Hollywood's secret was that the actors' shadows were too strong to have been created by streetlights at night, or if some foliage in the background of the shot appeared too light in color—and that's only *if* the audience noticed.

PHOTOGRAPHING WATER

In most infrared images, water records very dark gray or black because it tends to absorb all of the infrared radiation striking it. Water actually photographs in infrared in very

▶ **WATER RECORDS VERY DARK GRAY OR BLACK BECAUSE IT TENDS TO ABSORB ALL OF THE INFRARED RADIATION STRIKING IT.**

predictable ways: for instance, deep, dark pools of water will record dark in the final image, while white water will appear white. Very shallow water oftentimes appears transparent. The only real difference when using infrared is the strong contrast between the

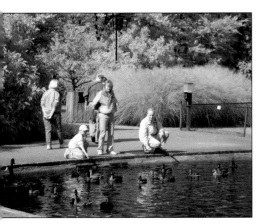

Deep water tends to be quite dark in infrared, while white water remains white in color. Photographs by Patrick Rice.

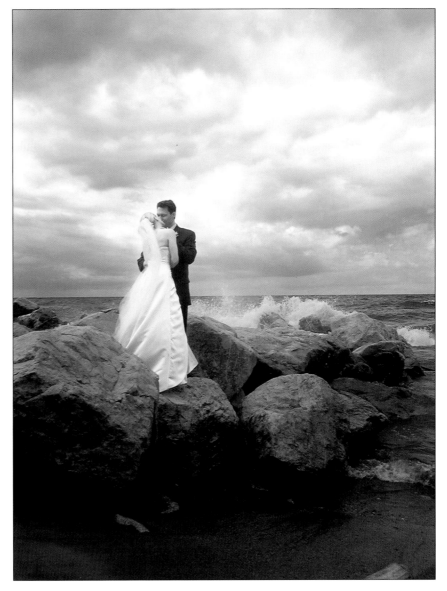

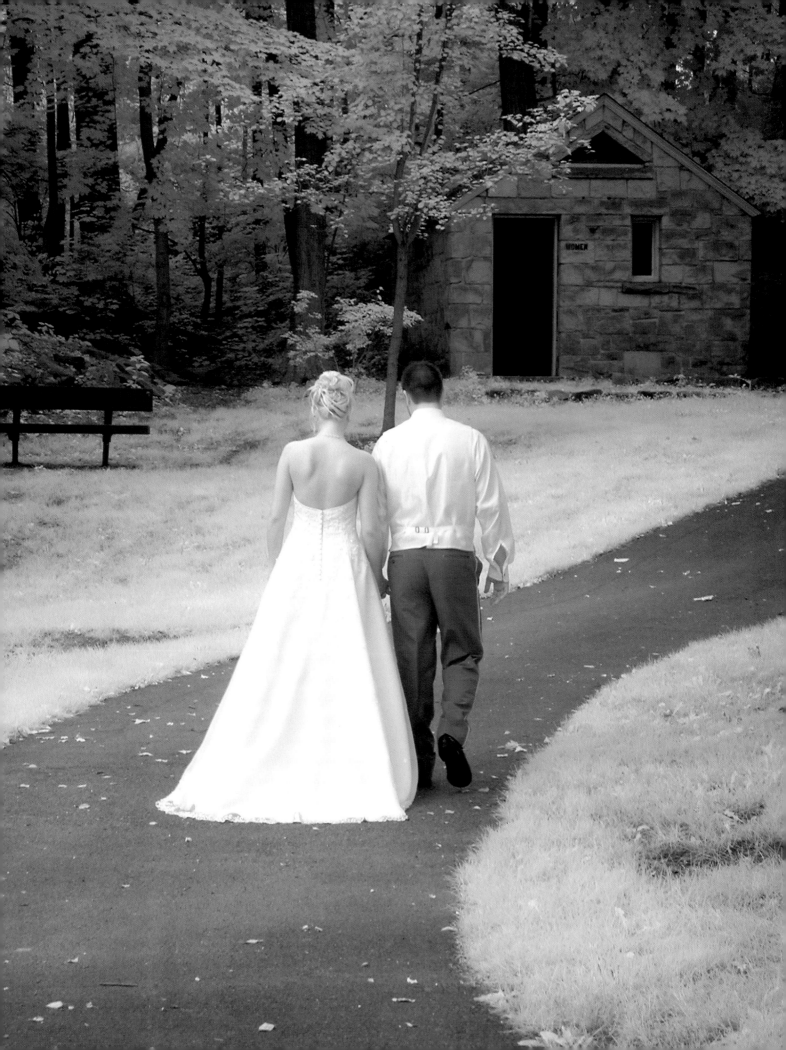

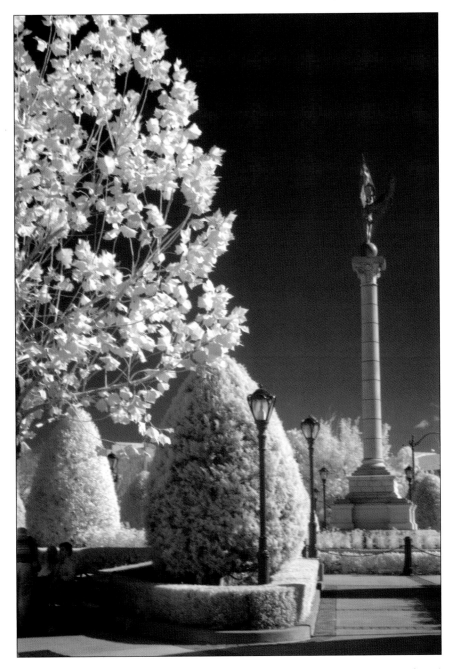

light and dark areas. This is helpful to remember when creating your scenic images in infrared. Just like the wonderful contrast we achieve between the snow-white trees and the near-black sky, we can create the same dramatic contrast with the near-black water and anything that is reflected on its surface. In infrared, water is almost a perfect mirror for anything nearby. Objects or people can be very striking if photographed near the water's surface. For that reason, we routinely create wedding images with the couple near the edge of ponds. These images are always among their favorites from the wedding.

BUILDINGS AND MONUMENTS

Many photographers don't think of buildings and monuments as interesting subject matter. Often light gray or white in color, they aren't too striking with normal photography.

What attracts photographers to infrared is the ability to create exciting compositions in an otherwise ordinary scene. In infrared photography, the inclusion of buildings and monuments can add contrast to the overall scene.

The inclusion of buildings or monuments can add contrast—and visual appeal—in infrared photos. In the above image, the contrast and texture combine to form a memorable shot. Photograph by Monte Zucker. Photograph on the facing page by Patrick Rice.

Most buildings that are dark will photograph dark and those that are light will photograph light. Some red-toned or red brick buildings will photograph very light gray—or even white—depending on the filter used in front of the camera lens.

Since blue skies turn almost black in infrared, light-colored buildings and monuments can be used just like clouds to add contrast to the scene. Dark-colored buildings and monuments are used in the same manner against lighter skies or light trees. Infrared photography

has a much higher contrast ratio than most color and normal black & white images. It is this dramatic contrast that makes the infrared image more unusual.

With a cloudless sky, monuments can take on an eerie glow that gives the impression the image was taken by moonlight. Images like these often give novice photographers the notion that infrared film and digital infrared record heat. However, this is not the case: in fact, only specialized infrared video equipment—not ordinary camera equipment—can detect the wavelengths of heat.

METAL OBJECTS

Metal objects do not reflect much infrared radiation and appear a shade of gray that corresponds to the color of the object. This is useful to the creative infrared photographer because the contrast between a dark metal object and trees rendered white in infrared can be quite

High contrast helps to set off this monument in an image that delivers the grandeur of Hollywood. Photograph by Monte Zucker.

striking. As mentioned earlier, piercings on a person's body also have a very strong contrast with the skin tones, which appear lighter with infrared.

Metal objects that are painted can photograph differently with infrared. For instance, if a car is painted a medium-red shade and a #25 filter is used in front of the camera lens, the car will record pure white. Other colors will record in differing shades of gray.

I once had a bride and groom who used their restored white 1955 Chevrolet automobile as their mode of transportation on their wedding day. Travis took some infrared images of the couple near the car, while I shot in color. When we looked closely at the images, we noticed that the driver's-side door was a slightly different shade of white than the rest of the auto-

▶ **PIERCINGS ON A PERSON'S BODY ALSO HAVE A VERY STRONG CONTRAST WITH THE SKIN TONES, WHICH APPEAR LIGHTER WITH INFRARED.**

mobile. Without infrared rendering, this difference was completely undetectable to the eye. The door was apparently repainted separately from the rest of the car. This information can be valuable to anyone purchasing an older car. Using infrared imaging as a tool to detect a repaint situation can influence the price of a car that is purported to be original or never damaged.

Rust is not an applied coating like paint, so it records very dark gray in infrared. Rusty old cars or trucks are common outdoor studio props for many high school senior photographers. The dark-gray vehicle provides a stark contrast to the trees and grass, which record light-gray or white in infrared.

You can incorporate a wide variety of metal elements—from graceful statues to structural elements—in your photograph for added contrast. Photograph on left by Barbara Rice. Right-hand image by Richard Frumkin.

Chapter 9

WEDDINGS AND PORTRAITS

Now that you've investigated the technical aspects of using infrared, you're ready to put it to use. This chapter describes how you can capitalize on the popularity of this intriguing style to set your studio apart, expand your creative options, and increase your profits.

WEDDINGS

A Growing Trend. As mentioned earlier, infrared imaging really strikes a chord with many of our wedding clients. In fact, the majority of our wall-size wedding portrait sales are comprised of infrared images. Perhaps it's the fact that our vision is limited to the visible spectrum that makes the recording of the invisible that much more interesting. Whatever the reason, clients' interest in this intriguing medium is growing, and in response, photographers across the country are integrating digital infrared into their repertoire.

▶ **A FULL 75 PERCENT OF ALL OF OUR WALL-SIZE PRINT ORDERS ARE NOW DIGITAL INFRARED WEDDING PORTRAITS.**

The appeal of infrared wedding photography is difficult to measure, but it is certainly significant. In fact, outside of scenic and landscape photography, wedding imaging is by far the most popular infrared genre in the United States.

Infrared wedding photography is also the most commercially viable area of infrared imaging. We sell infrared images to every bride and groom that we photograph. A full 75 percent of all of our wall-size print orders are now digital infrared wedding portraits. Our pseudo color-infrared images (see pages 73–77) are also becoming very popular with our wedding couples. They are just different enough to make them desirable to some brides and grooms. In fact, we have had a number of couples choose a pseudo color-infrared wedding image for their wall-size print.

Many of our wedding clients now choose pseudo color-infrared images for their edgier feel. Photographs by Travis Hill.

Practical Advantages. We have been photographing weddings in infrared for many years. Although we were using Kodak infrared film when my wife, stepson, and I wrote *Infrared Wedding Photography* (Amherst Media 2000), our philosophy remains the same for digital infrared. We were then and still are looking for ways to provide brides and grooms with unique and memorable images from their wedding day. Infrared photography has always fulfilled that desire.

Since making the transition from shooting infrared film to shooting strictly digital infrared, we've consistently produced great infrared wedding images. No longer do we have to bracket our exposures to get a few good images. No longer do we have to worry about how the film is handled. No longer do we have to wait until the film is processed to know what we created.

▶ **DURING A WEDDING SESSION, THE BRIDE AND GROOM EXCITEDLY VIEW IMAGES TAKEN JUST MOMENTS BEFORE.**

The ability to view images on an LCD screen is also a clear advantage to clients. During a wedding session, the bride and groom excitedly view images taken just moments before. We are able to sell the couple on the infrared images even before they are printed. We show them to the bridal party and parents as well.

Drawing Business. Our ability to showcase our talents on the day of the clients' wedding adds to our credibility and leads to future business. Barbara routinely brings a Canon CD 300, a small dye-sub printer, along with her when she's shooting weddings. At the beginning of

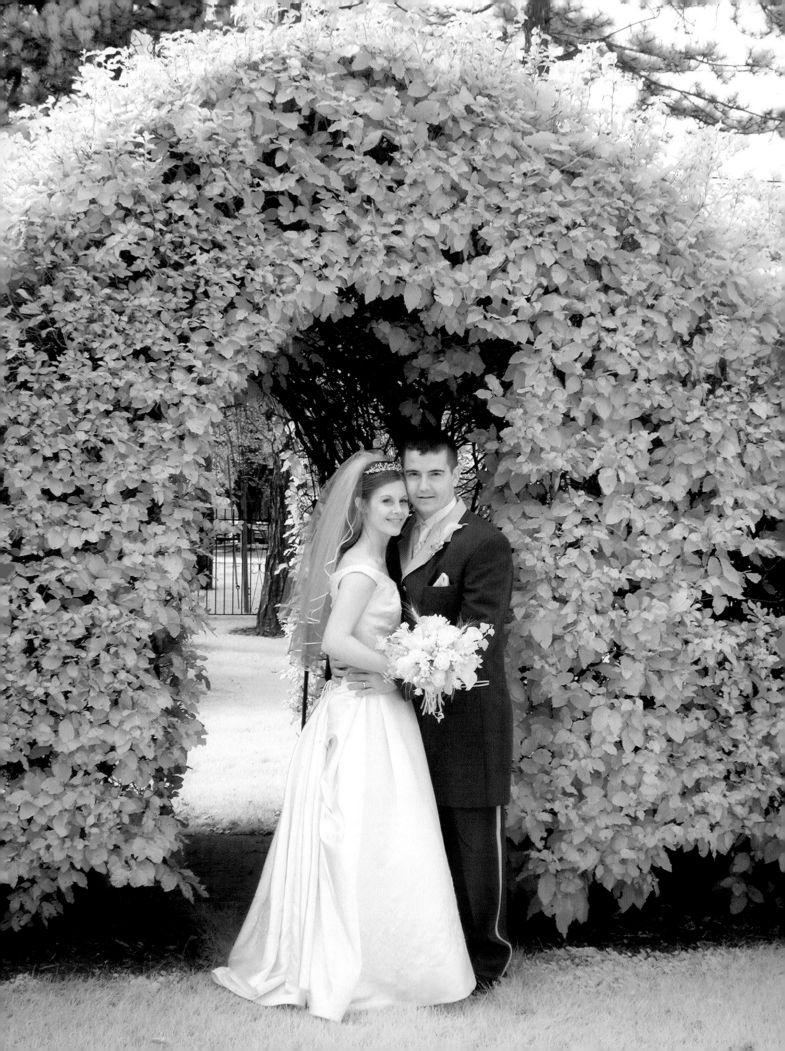

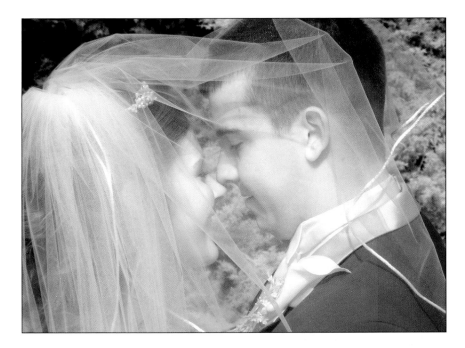

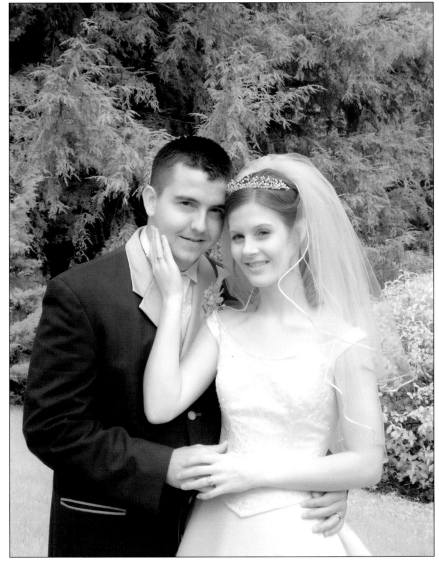

the reception, while the couple is busy with their receiving line or sharing cocktails with their guests, she sets up this printer to make a digital print from the day's event. In many cases, Barbara chooses to print a digital infrared image of the couple that she shot in the park (or a similar picturesque location) just moments before arriving at the reception site. She simply loads her CompactFlash card directly into her printer, views the photos on a mini monitor that's located right on the printer, and selects an image to print. She then prints three identical images—one for the bride and groom and one for each set of parents. These 4 x 5-inch images are placed into a folder with our studio imprint on it and given out at the beginning of dinner while everyone is seated.

The response to these digital infrared images has just been incredible. Invariably, Barbara's photographic artistry becomes the overwhelming topic of conversation as these prints are shared with friends and family. More importantly, the entire room full of guests is exposed to digital infrared photography. The public relations value of this minimal investment (under $5) cannot be measured. We have had so many compliments about

Being able to print images for display at the reception will create excitement among the guests. Photographs by Fallon Miller.

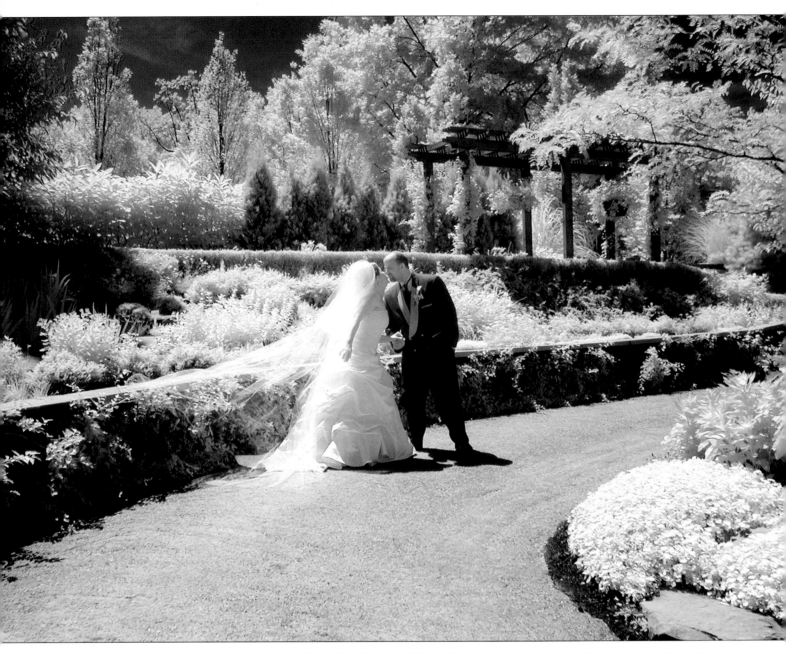

these prints, and many new clients have booked weddings because of them.

Pushing the Boundaries. Everywhere you look, you'll find more evidence that infrared photography is favored by both clients and photographers. It's made quite a splash in the industry: Many national bridal publications have showcased infrared wedding photographers in their magazines and on their websites. Photographers Ken Sklute, Ferdinand Neubauer, Richard Beitzal, Don Emmerich, Gary Fong, and others have been producing infrared wedding images for many years with great success. Others, like Connecticut photographer Laurie Klein, are enhancing their portraits through traditional and digital means. For instance, Laurie often adds spot color to her exquisite

Many brides request information on infrared imaging during their pre-wedding consultations. Photograph by Travis Hill.

infrared wedding images. My stepson, Travis, often enhances black & white infrared images by applying a sepia tone. Barbara, Travis, and I, in addition to writing a book on the subject, have been featured in Ed Pierce's *Photo Vision* video magazine series and in *Rangefinder* magazine. All of the photographers in our studio are also accomplished in the art of digital infrared imaging.

As a result of the efforts of these and other photographers, many brides today now ask specifically about infrared imaging on their wedding day. The message has certainly reached them.

PORTRAITS

Portrait photography provides a very exciting opportunity for infrared imaging. Many photographers have seen the lucrative opportunities in portraiture and capitalized on them. At our studio, we have provided our portrait clients with infrared images for many years. Infrared provides a unique look to any portrait and can actually be much more flattering to the subject.

Photographing High School Seniors. Over the last year, we have begun creating many more of our high school senior portraits in infrared. With digital infrared photography, the client can immediately see the images that were just recorded. This has proven invaluable for raising our senior session profit averages. Today's seniors are looking for something different in their portraits. Infrared provides a unique look that seniors are unfamiliar with, but they appreciate it. As mentioned earlier, infrared photography offers another great advantage when photographing high school seniors: the appearance of acne is diminished or, in some cases, eliminated in infrared.

Seniors are always on the lookout for images with an extra edge. Infrared fits the bill and is a popular option for many clients. Photographs by Patrick Rice.

Infrared portraits can be just as versatile as a standard black & white or color portrait. Feel free to use interesting backgrounds and integrate props that add personality to the image. Photographs by Patrick Rice.

We have also received a very favorable response to the pseudo color-infrared portraits we've created for senior clients. They love the strange coloration of the images with the camera left in the color mode (for information on creating these images, see pages 73–76).

Fine Art Portraits. Many studios have been successful with fine art infrared portraiture. Usually more graphic in nature, these infrared images include much more of the client's surroundings than a typical portrait. Photographers take advantage of the wonderful attributes of infrared to create timeless images that are simply breathtaking. Infrared environmental portraits resemble classic art. The softness and grain give a Monet-like appearance to the image. Fine-art infrared children's portraits have an old-world, timeless quality. All of these photographers are reaping financial success from this medium.

MARKETING

Advertising is sometimes defined as letting customers know that you are out there. *Marketing,* on the other hand, is getting those customers to choose your services instead of signing on with one of your competitors. If you want to maximize your infrared sales, you need to *market* your services. You must get the word out about the unique style of photography that you are producing. Separating yourself and your photography from run-of-the-mill studios that produce cookie-cutter work will win the business of your desired demographic.

While the majority of our infrared images are sold to wedding clients, I believe that each and every client should be shown the beauty of infrared imaging. This section focuses mainly on marketing infrared wedding images, since at our studio, the genre is most popular with brides and grooms. However, many of the ideas can be used to market infrared portraits.

The Beauty of Infrared

Black & white infrared photography is the most mysterious and intriguing form of photography in existence. Infrared photographs are sometimes bold, sometimes dreamlike, but always interesting. The images almost appear as if they will float off the paper.

Part of the mystery about infrared imaging is that so many factors affect the final image. Time of day, conditions of the sun, clouds, sky—and even the rotation of the earth—have an affect on the photo. This unpredictability is one of the reasons why only a handful of photography studios across the country even offer infrared images to their customers.

At Rice Photography, we have studied the intricacies and nuances of this complicated and intriguing medium.

Through extensive research and experimentation, we have become the leading proponents of infrared wedding photography throughout the world. Our work has been featured in magazines, books, and even instructional videos as a teaching aid for photographers looking to venture into the unique spectrum of infrared. We have been asked to lecture and teach the techniques we have learned across the country. In 1999, we were asked to share our knowledge with photographers worldwide, and in the year 2000, Amherst Media, Inc. published our book, *Infrared Wedding Photography*. This is the only book ever published that deals exclusively with infrared wedding-day images.

Client Handouts. From the days when we were shooting infrared film to the present, we have always made sure that the buying public knew we were different. To earn customer loyalty and increase profits, we give the following handout to our potential wedding clients; we give a slightly reworded version of the piece to portrait clients.

Some photographers may read that handout and feel that I am conceited. The fact is, it doesn't matter all that much to me. Photography is both my passion and my livelihood. As a full-time professional photographer, I need to make money in this business to pay the mortgage and put food on the table. I have never been one to buy into the romantic notion of "the starving artist." I want to be a successful artist.

Infrared imaging is indeed artistic. However, your clients won't necessarily recognize infrared photographs as such, even after they have viewed your infrared photographs. It is important to educate the client to the differences between your studio and others—and the advantages of choosing you as their photographer.

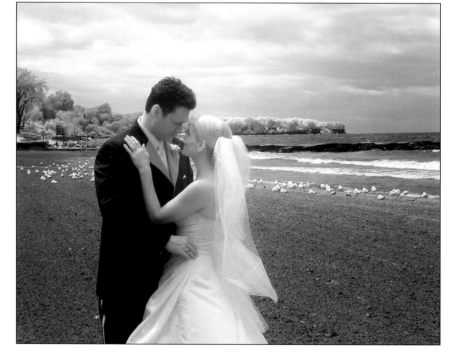

Showing your potential clients infrared images will whet their appetites for something a little different and can provide the impetus for larger sales after the wedding. Photographs by Patrick Rice.

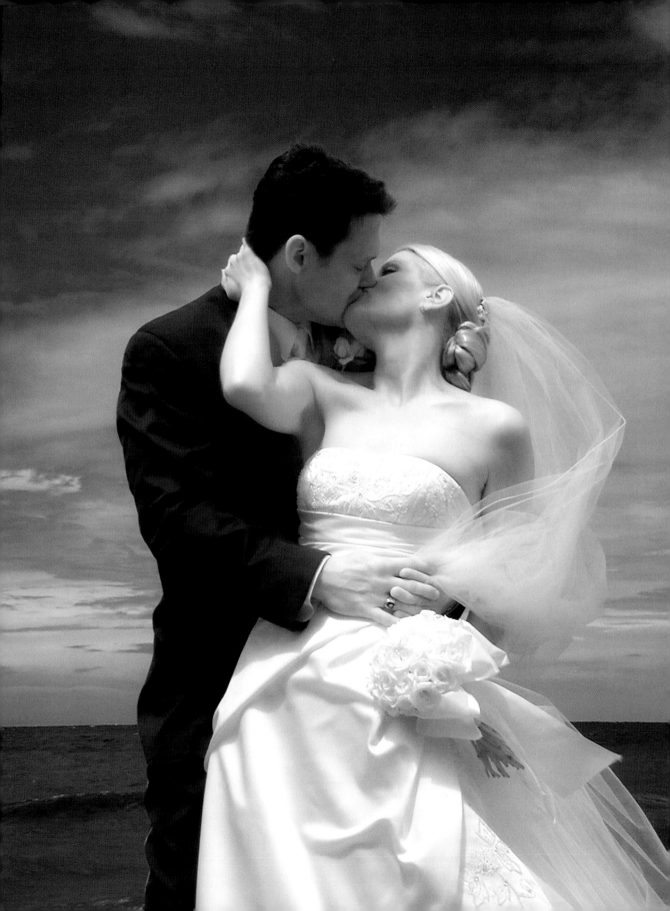

Combatting Customers' Fears. When our studio made the transition to digital wedding photography a couple of years ago, we found it necessary to educate the clients as to the advantages of hiring a digital photographer. Amazingly, many photographers are still to this day claiming that digital photography is inferior to film. To combat this misinformation, we wrote the following handout, which is given to wedding clients (a variation of the form is provided to portrait clients as well!).

Why You Should Hire a Digital Photographer

Technology continues to change all aspects of our lives. This is especially true in the field of photography. Although many photographers refuse to embrace digital imaging, it is the best choice for both the photographer and the bride and groom on their wedding day.

There are many advantages to digital photography. This discussion only touches upon a few of them.

First, with digital cameras, the photographer receives visual confirmation of each image that they create through viewing the LCD screen on the back of the digital camera. Further, the photographer can analyze the image in detail—checking both exposure and quality in a matter of seconds. With film cameras, the photographer never really knows what the images will look like until the film has been processed and printed at the lab. A photographer with a film camera could be experiencing mechanical problems with the camera but never know it until it is too late. This exact experience has plagued photographers for decades—that is, until now.

With digital cameras, a photographer instantly knows if there is a camera problem, mistake in exposure, etc. The photographer will never take two bad pictures in a row. This is quite a relief for the bride and groom, who are entrusting their photographer to record memories of their special day.

Second, digital photographers now have complete image security. With film cameras, the photographer had to send the exposed film to the lab. There was always a risk that the shipping service would lose or damage the film. Further, once the film arrived at the lab, there was the possibility the lab could lose or damage the film. In both cases, the photographer could do everything right, and yet the bride and groom could fail to get any photographs.

With digital photography this is no longer the case! The photographer records each image onto CompactFlash media storage cards. Once the photographer returns to the studio, he or she transfers the images from the CompactFlash cards onto compact discs. These CDs never leave the studio. The photographer then copies the digital images on the CD to a duplicate disc and sends that disc to the lab for the making of the photographic prints.

The labs use the exact same machines and photographic paper to make prints whether they were created with film or digitally. Moreover, if the disc is lost or damaged in transit or at the lab, the photographer can burn another copy and resend the image files. The bride and groom never have to worry that anything will happen to their priceless images.

Third, digital photographers can capture every image in color but are free to make any color image into a perfect black & white photograph with absolutely no loss in quality. This is not possible with film, where there was always some quality degradation when making a color image into black & white. In addition, sepia toning and color toning of digital images is much easier and less costly than with film images.

Last, there is much more flexibility in the cropping of digital images. With film, the photographer must use standard cropping sizes (utilizing tools known as masks or crop cards). These crop cards do not always allow the ideal cropping of an image. With digital images, cropping is much more flexible and can be used to maximize the photographic quality of each of your wedding images.

These are just some of the many reasons why the obvious choice for every informed bride and groom is to select a digital wedding photographer!

We have always been strong advocates of giving potential wedding or portrait clients actual examples of our photography. We have promotional cards printed with images like this one to allow clients to take home an example of our work to show to their friends and family. Photograph by Patrick Rice.

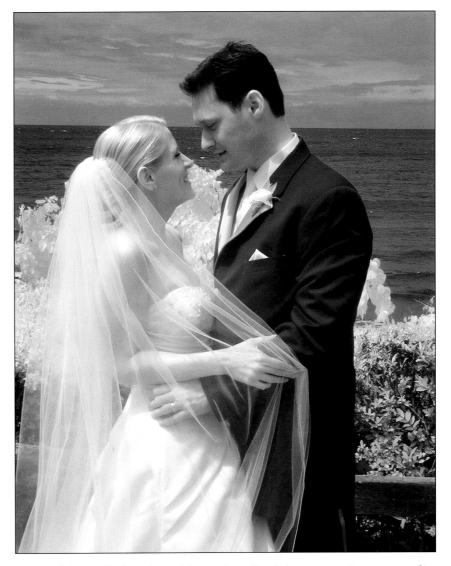

For this particular piece, I intentionally did not mention our studio name. I did this because I felt the piece was more factual and less of a promotion for our particular business. I want all couples to choose a digital photographer for their wedding photography—no matter which studio they choose.

> ▶ **WE HAVE ALWAYS BEEN STRONG ADVOCATES OF GIVING POTENTIAL WEDDING OR PORTRAIT CLIENTS ACTUAL EXAMPLES OF OUR PHOTOGRAPHY.**

Promotional Cards and Tear Sheets. We have always been strong advocates of giving potential wedding or portrait clients actual examples of our photography. We purchase very high-quality printed cards that showcase our photography, and we give them to any customer who inquires about our services. We have used ABC Pictures (www.ABCpictures.com) for much of our printing. The lithographed prints they produce are on heavy, semigloss-coated stock, and they use a fine line screen. They so closely resemble original "glossies" that the difference is seldom noticed. The company will design your cards from

Here are two examples of the promotional cards we give to prospective clients.

photos or image files in any size at no extra cost. All of their prices are wholesale. The amount of markup you charge is up to you. Photographers have a particular advantage here when part of their service is producing the original photograph.

Marathon Press (www.Marathonpress.com) is recognized as the industry leader for promotional printing and has provided a great service for many a portrait studio—ours included—for over a decade.

Marathon also produces the Professional Photographers of America's Loan Collection and Showcase books. Our success in photographic competitions has earned our studio inclusion in these fine publications. Whenever an image is used in one of these books, the photographer has the opportunity to purchase tear sheets and promotional cards at a significant savings. We have always taken advantage of this substantial discount in printing for all of our award-winning images—including black & white infrared. One of our current handout pieces is a black & white infrared image that my stepson Travis took and then sepia toned. This beautiful glossy card makes a very favorable impression on our clients.

▶ **THESE CARDS ARE VERY HELPFUL WHEN NOT ALL OF THE DECISION-MAKERS ARE PRESENT AT THE INITIAL CONSULTATION FOR OUR SERVICES.**

In recent years, we have made all of our handout image cards from digital images. That now includes a digital black & white infrared card. These cards are very helpful when not all of the decision-makers are present at the initial consultation for our services. It is especially helpful when the bride wants to show the absent groom or parent what is so special about infrared wedding imaging.

Simulating the look of infrared in Photoshop is remarkably easy.

1. To begin, open a color image (you must start with a color image for the technique to work). An outdoor image containing grass and trees, like Image 1 (photographed by Patrick Rice), is a good choice. Set the image mode to RGB (Image>Mode>RGB).

2. Duplicate the background layer (Layer> Duplicate Layer), and name this layer "channel layer" (Image 2).

3. With the new, duplicated layer (labeled channel layer) activated, activate the channel mixer (Image>Adjustments>Channel Mixer). See Image 3.

4. Click the "monochrome" box at the lower left of the dialog box. This will set the output channel to gray. Next, set the red slider to −70 percent, the green slider to +200 percent, and the blue slider to −30 percent

(Image 3). You should see the infrared effect begin to appear in the photo, as is evident in Image 4.

5. With the "channel layer" still activated, switch from the layers palette to the channels palette (View>Channels). Select the green channel (Image 5).

6. Next we'll give the image its characteristic infrared glow. With the green channel still activated, go to Filter>Blur>Gaussian Blur and select a blur of 5 pixels (Image 6).

7. Applying the Gaussian blur will destroy all focus in the image, so after doing so, simply go to Edit>Fade Gaussian Blur and reduce the effect to about 25–35 percent, depending on your preference. To restore (continued)

Image 1

Image 2

Image 3

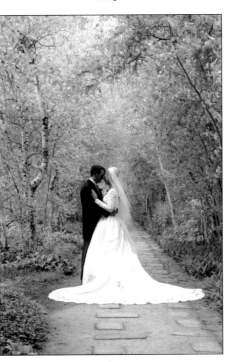

Image 4

Image 5

Gaussian Blur

Radius: 5 pixels

Image 6

sharpness to the subjects, you can use the History brush, setting the source to the "channel mixer" state in the history palette.

8. You can now flatten the image (Layer> Flatten Image).

9. The final touch (which may be applied to whatever degree you like, or not at all) is to add an increased appearance of grain. To do this, go to Filter>Noise>Add Noise (Image 7). Choose "Gaussian" from the buttons at the bottom of the box. Click the "monochromatic" button at the bottom of the box to ensure only neutral gray noise is added.

Your final image should look something like Image 8. As you can see, this represents a sig-

nificant difference from a straight grayscale conversion (Image 9).

Depending on the tones and colors in the image you select, you may need to adjust the settings in the Channel Mixer (step 4) to optimize the effect. If you want to maintain the original brightness of the image, make sure that the percentage values for the three sliders total +100.

For images without many green tones (Image 10 [photograph by Jacob Jakuszeit]), you may find it helpful to tweak the Curves before applying the Channel Mixer. A straight

conversion with the Channel Mixer made the skin tones too dark in this case (Image 11). To compensate, the image was lightened by pulling down on the center of the composite curve (Image>Adjustments>Curves), and the curve for the red channel was pulled down to give the image a green/blue cast. After applying the channel mixer and playing with the settings a bit, the results were much better. The rest of the previously discussed procedure was then followed from step 5 (Image 12).

Image 7

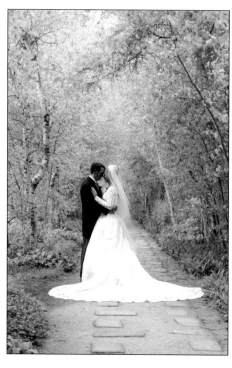

Image 8

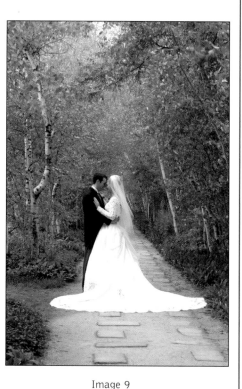

Image 9

Image 10

Image 11

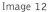

Image 12

PRINTING STRATEGIES

To this point in the photographic process, you've done the best you can to achieve technically correct, highly artistic images. Printing the image is the next step. To ensure the best-quality output, follow the tips outlined in this chapter.

PREPARING YOUR IMAGE FILES

Digital imaging puts many helpful creative controls right at your fingertips. Whether you're doing your own printing in-house or relying upon lab services, you'll find that these techniques will improve the quality and salability of your images.

Enhancing Contrast. As discussed earlier, when shooting infrared images, you may want to increase the range of tones in the image (to review the process, see "Troubleshooting Tips for Digital Infrared Imaging" on page 78). One of the big advantages of digital imaging is the photographer's ability to set the black and white points for any particular image. This is especially helpful with black & white infrared photographs. If the black tones in the image are not very rich and saturated or appear muddy, the photographer can import the image into

Using Levels will help you to fine-tune the contrast for improved images. Note the change in the image that results when the sliders are moved from their original position (left image) to just under the histogram data on the right and left edges (right image). Photographs by Barbara Rice.

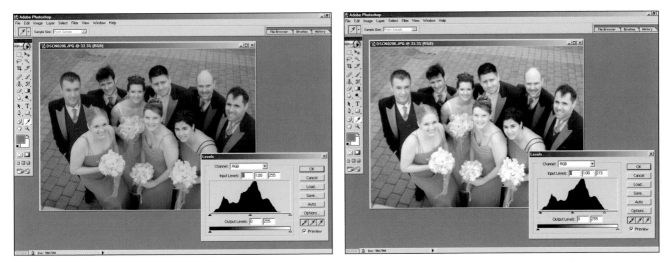

Photoshop and go into Image> Adjust>Levels to fix it. In Levels, you can reset the black point to the darkest area on the image and make it 0 black. The same is true for the white areas in a digital image. Using the same Photoshop tool, you can reset the white point to 256 (absolute white). So, if there is any area that you know was white in the image, you can make it pure white through Levels. In this manner, you can create a high-quality image for printing that will have good contrast and good midtones.

With infrared film, many of my exposures looked weak or muddy, and I would simply dispose of these photographs. With digital infrared, even inaccurate exposures can significantly improved through some simple Photoshop work. My clients see almost every exposure that I make because there are no longer unacceptable prints.

Adding Noise or Grain. If you've used Kodak infrared film, you've undoubtedly noticed its sharp yet grainy appearance— and you might wish to re-create that look. Fortunately, doing so is easy. In Photoshop, just go to Filter>Noise>Add Noise, enter an amount (5 is a good starting point), click Gaussian, and check the Monochrome box. Alternatively, you can go to Filter>Artistic>Film Grain for a different effect.

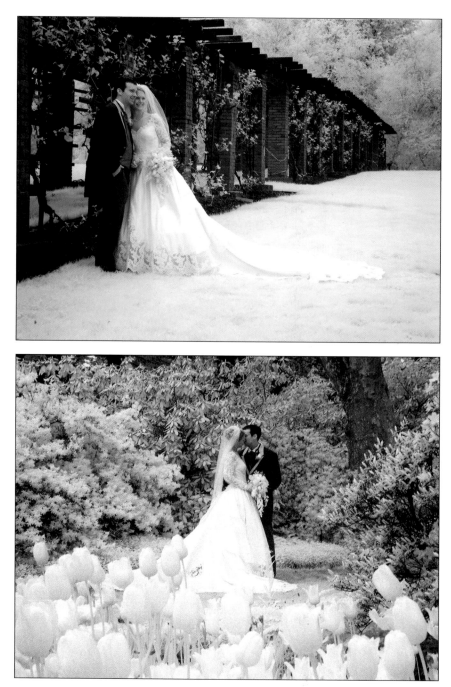

Taking the time to use Levels to ensure that the blacks in the image are rich and the whites are crisp will ensure your images are the best they can be, while adding "film grain" in Photoshop will help to mask pixelization in large images. Photographs by Tony Zimcosky.

Turning Small Image Files into Large Prints. Digital cameras have small file sizes. When those little files are used to create the wall-sized images our clients love, pixelization is often an inherent problem in the print. Fortunately, this can be masked with the addition of noise or grain. I've found that adding noise in small doses produces the best

results. In other words, rather than adding 15 percent in the noise Amount field, I prefer to add 5 percent noise three times.

LAB PRINTING

When it comes to digital photography, no topic strikes fear in a client's heart quite like digital output. With so much information on digital imaging available to novices and pros alike, our customers have heard tales about poor images quality and fading prints. Some are convinced that their images could just as easily be printed at home on their inkjet printers, with matched quality. Additionally, both consumers and photographers sometimes try to enlarge digital images beyond the point of acceptability, and the over-enlarging of these digital images produces a high degree of pixelization.

▶ **BOTH CONSUMERS AND PHOTOGRAPHERS SOMETIMES TRY TO ENLARGE DIGITAL IMAGES BEYOND THE POINT OF ACCEPTABILITY.**

The truth is, digital imaging has evolved. First of all, it is not necessary for the professional photographer to print any of his digital images. Just about every professional color lab on the globe can now accept digital files and make prints on Kodak or Fuji photographic paper. Moreover, these labs use the same machines to print from both negatives and transparencies or digital files. This is a very important selling point when we discuss digital imaging with the clients.

Some clients fear that their digital prints will not last. This is due in part to experiences with early inkjet prints and is fueled by misinformation they've gleaned from publications and photographers. Once we explain that the same Fuji Frontier printer is used to create prints captured on both film and digital cameras and that both film and digital images are printed on Fuji Crystal Archive Paper, they are more comfortable with the fact that we are a digital studio.

IN-HOUSE PRINTING

Many studios, including ours, use in-house inkjet or dye-sublimation (dye-sub) printers for specific applications.

In our studio, we've used the Epson 2000P and the newer Epson 2200 inkjet printers to output images for clients who need a quick turnaround on their portraits. These printers also work extremely well for making watercolor prints. We've been very pleased with the quality images that they produce.

We have used a small Canon CD 300 dye-sub printer for many years to produce high quality digital quick prints at wedding receptions. Dye-sub printers produce very fine quality digital images that are superior to all but the best inkjet printers. We select one digital image taken

during the wedding day, print three copies of the image, and place each one inside a folio with our studio imprint on it. We then present these portrait miniatures to the bride and groom and to each set of parents during the reception dinner. This helps us to showcase our work and attract more clients at a

▶ **SENDING THE BALANCE OF OUR IMAGES OUT TO A LAB FOR PROFESSIONAL PRINTING IS THE BEST AND MOST COST-EFFECTIVE OPTION.**

cost of about $1 per print and 50 cents per folio. The payoff is certainly worth the modest investment.

While printing such photos in-house can be advantageous, we've found that sending the balance of our images out to a lab for professional printing is the best and most cost-effective option. First, when

When you've taken the time to create a quality image, you'll want to make sure it's also beautifully printed. Photograph by Michael Ayers.

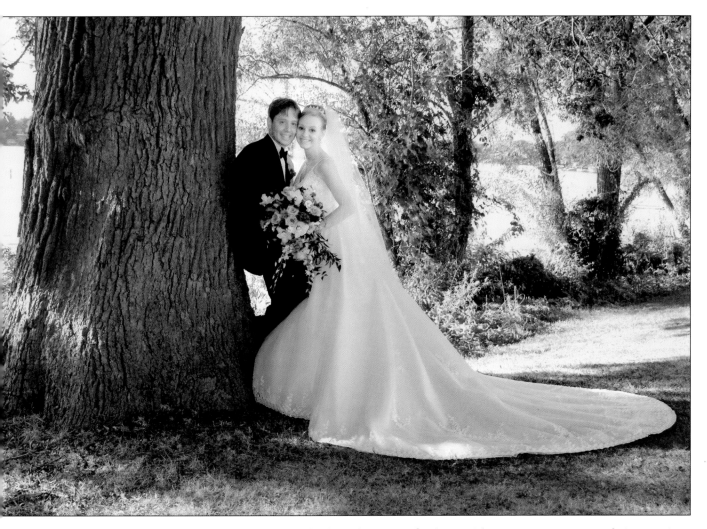

Many clients have misconceptions about digital photography and expect poor image quality; they've heard rumors about fading prints. It's up to you to explain the benefits of digital capture and to show the stunning results. Photograph by Michael Ayers.

you calculate the cost of ink cartridges, paper, waste, and time, prints made in-house cost more than those made at the lab. Second, the professional color labs can better produce images that are more consistent in color and density than those produced in most studios. I know several photographers who have attempted to print 8 x 10-inch images of a bride and groom on their inkjet printer, only to have the couple reject them for lack of quality when compared to a lab print. Though the new generation of inkjet printers can produce high quality images, the photographer must maintain proper calibration of their monitor and printers to carry it off.

▶ **THE PHOTOGRAPHER'S ABILITY TO PRINT THEIR OWN IMAGES IN-STUDIO HAS SPURRED MUCH COMPETITION AMONG OTHER PROCESSING LABS.**

Although numerous photographers print their own 4 x 5- or 4 x 6-inch proofs, such printing is not cost-effective. However, the photographer's ability to print their own images in-studio has spurred much competition among other processing labs. Many larger discount and department stores (i.e., WalMart and Sam's Club) can produce proofs from a Fuji Frontier Printer on Fuji Crystal Archive paper at a

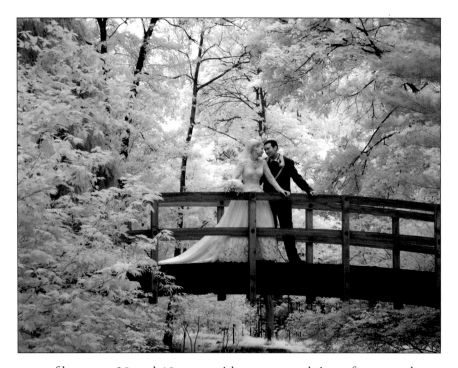

cost of between 20 and 40 cents with turnaround times from one hour to next day. Professional color labs have also become more competitively priced in the area of digital proofing. The bottom line is, your color lab can produce your proofs far less expensively than you can.

PAPER SELECTION

The printing of infrared images is not significantly different than that of any other black & white printing. With most black & white prints, we want deep, rich blacks and clean whites. We usually look to cover all of the tones of gray with a good contrast ratio. Most commercial color labs are more than capable of making high-quality black & white and infrared prints.

With traditional infrared film, most prints are made on a black & white paper. With digital infrared imaging (or scanned infrared film negatives), images are printed on a

▶ **MOST COMMERCIAL COLOR LABS ARE MORE THAN CAPABLE OF MAKING HIGH-QUALITY BLACK & WHITE AND INFRARED PRINTS.**

color paper. Therefore, if the tones in the digital image file are not neutral, the final image could have a color cast to it, even though it is predominantly a black & white image.

Color casts appear more frequently in prints that photographers are making themselves with their in-studio printers. Many printer companies, including Epson, have added special inks to their ink cartridges for improved black & white results. Good color calibration software is also readily available for studio printing, and taking the time to use such programs can ensure better-quality black & white results.

FINISHING TOUCHES

Once your image is printed—or ready to print—you may wish to enhance your image through toning, handcoloring, or framing.

TONING INFRARED PRINTS

For many years, photographers have appreciated the value of toning photographs. From the earliest days of photography, toning black & white images has added immensely to the impact of certain photographs. In recent years, photographers around the world have experimented with numerous toning techniques to convey their visual messages. This is especially true of infrared images. Infrared photos take on a strangely beautiful look when sepia toned. To the untrained eye, they are monochromatic color images that are strikingly different from all other photographs. Most people do not readily identify infrared images that have been toned. They are different enough from normal black & white prints to be interesting and intriguing.

Image-makers have employed traditional sepia toning of black & white photographs for decades. Sepia toning is a time-consuming process, and the photographer must cope with the less than aromatic smell of the sulfur-based chemistry. (For an introduction to the traditional toning process, see *Toning Techniques for Photo-*

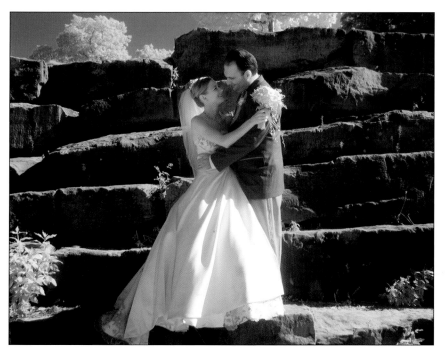

Toning effects can be subtle or vivid and can be applied by traditional means or using Photoshop. Photograph by Travis Hill.

graphic Prints by Richard Newman [Amherst Media 2003].) More recently, photographers have created the "sepia look" in their black & white images via numerous alternative methods. When I began learning photography, I made sepia images in the traditional manner. I later learned that I could achieve a sepia look by dipping the print in black coffee or tea. It was not the same as real sepia, but it did provide the

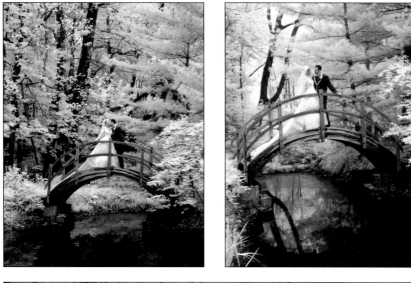

One image, presented two ways. As explained on page 124, digital toning can be easily accomplished—with remarkable results. Here, the original black & white image was given a rosy hue. Below, the same scene was differently composed and toned in a cool blue for a very different look. Photographs by Tony Zimcosky.

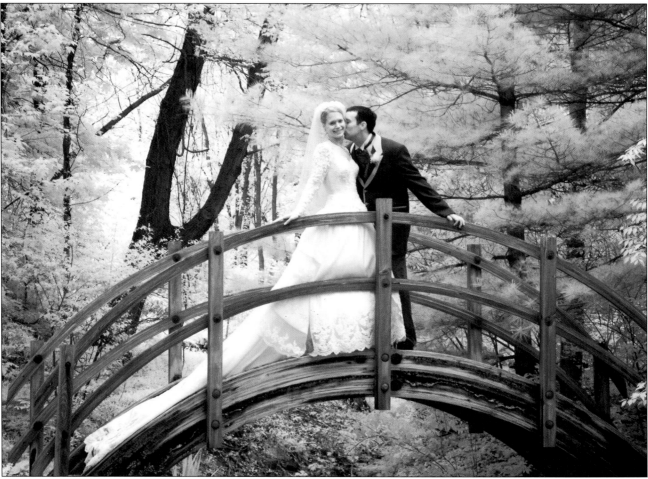

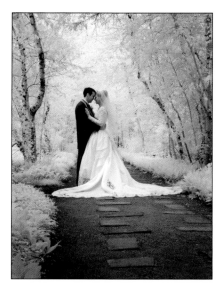

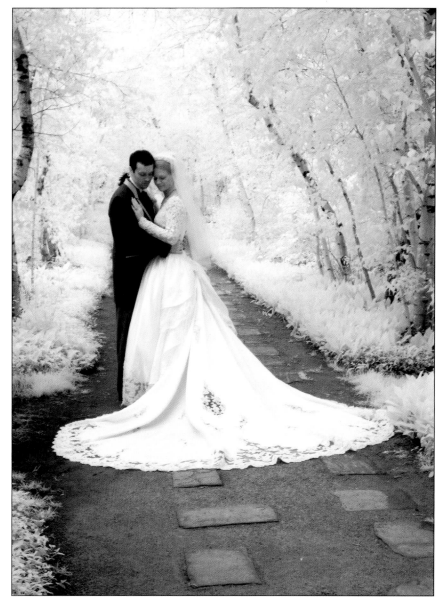

The sepia tones in the image on the right create an entirely different feel than is achieved by the original image (above). Photograph by Tony Zimcosky.

brown tone that most clients are looking for. Professional color labs also began creating the "sepia look" by printing black & white images on color photographic paper and dialing-in the brown tone that was desired.

Today, we are in the age of digital imaging and digital printing. With digital infrared imaging, adding a sepia look to an image is as simple as using the built-in action in Photoshop. In Photoshop (version 7 and higher), simply open the Actions palette and click on Load Actions. This will load several actions that are built into the software and available for the photographer to use. The Sepia action is exceptionally accurate, and the photographer has the ability to make adjustments to suit his or her particular tastes. I am always surprised to find how many photographers are unaware of this hidden action in Photoshop. You can also create the sepia look through many of the

other image adjustment tools in Photoshop. Some photographers prefer to customize each image through the Curves adjustment or other tools. It is completely up to you how you create the sepia look. Personally, I prefer using the built-in Photoshop action to ensure that the sepia look from one infrared image to the next remains consistent.

In addition to sepia, other toner colors have also become popular. For many years, photographers have used color-specific toning chemistry for black & white images. This process produced adequate results, but the photographer had little control over the intensity of the color that resulted from the toning process. Professional color labs found a solution by printing black & white images on color photographic paper. Like with the sepia or brown-tone look, color labs can dial-in virtually any color imaginable.

▶ **IN TODAY'S DIGITAL AGE, THE PHOTOGRAPHER NO LONGER NEEDS TO RELY ON THE LAB TO CREATE COLOR-TONED IMAGES.**

In today's digital age, the photographer no longer needs to rely on the lab to create color-toned black & white or infrared images. Using Photoshop's image adjustment tools and a black & white image in the RGB Color mode, photographers can make their images any monochromatic color they desire. (Note that color cannot be added to an image unless the image is in a color mode.)

To do this, I prefer to use the Curves adjustment tool in Photoshop. When you go to Image>Adjustments>Curves, a graph appears showing a diagonal line from the bottom left to the upper right. To begin, click on the RGB pull-down menu at the top of this palette, you can choose to work exclusively within the red, blue, or green color channels—one at a time. For instance, if I want a blue-toned final print from my infrared photo, I simply click on the blue channel, then click on the diagonal line at a point about two-thirds from the bottom and drag the line up. This instantly shifts the image to a blue tone. You can vary the degree and intensity of the color by how far you choose to drag the line. The same can be done for the red and the green channels. The possibili-

One of the remarkable things about digital toning is that that you can freely experiment with colors and the intensity of its application. Photograph by Chad Tsoufiou.

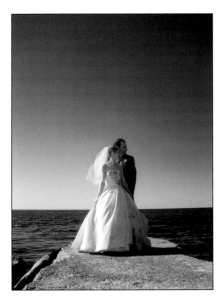

Here, the grays in the image were replaced by blue tones that give the image a more subtle toned effect. Photograph by Travis Hill.

ties are endless, and completing the process takes only a minute or two.

With digital imaging in general, and specifically digital infrared, toning images has never been easier. I now have complete creative control over the final look of my images. Black & white infrared images no longer need to be only seen in black and white. In many cases, toning the infrared image can add impact and interest to the final print.

HANDCOLORING

The art of handcoloring photographs dates back to the mid 1880s, just after the advent of photography itself. Originally created to add color to a colorless medium, the process evolved over the years but died out after the invention of color film. Because interest in the art form had much declined by the 1950s, most early practitioners passed away without teaching their craft to a new generation of photographers. Today, there has been a growing interest in the art of handcoloring, and new practitioners are once again picking up paints, pastels, and chalks—or relying upon image editing programs like Photoshop to impart selective color—to add a new dimension to their photographs.

My wife, Barbara, is credited by many for bringing this lost art back to the Greater Cleveland area and is considered the leading traditional handcoloring artist among area photographers. She has been handcoloring images for well over a decade and has shared her knowledge with members of several photographic organizations across the country.

Barbara has worked with all mediums to apply color to our images. She prefers to use art pencils for small areas and chalk or crayon pastels for larger portions of the image. Barbara has had a great deal of success with the handcoloring pen sets manufactured by Spot Pens. These colors can be easily blended and can also be removed if you make a mistake.

▶ **THE ART OF HANDCOLORING PHOTOGRAPHS DATES BACK TO THE MID 1880s, JUST AFTER THE ADVENT OF PHOTOGRAPHY ITSELF.**

If you'd like to try your hand at this, be sure to start with an image that's printed on matte paper. For more formal instruction on the art, consult *Handcoloring Photographs Step by Step* by Sandra Laird and Carey Chambers (Amherst Media 1997). If you prefer to go the digital route, see *Traditional Photographic Effects with Adobe® Photoshop®* by Michelle Perkins (Amherst Media 2004).

FRAMING INFRARED PRINTS

Many photographers miss a golden opportunity to generate a new income stream by not offering framing to their clients. This is especial-

ly true with infrared images. Many years ago, when infrared wedding images became a regular part of every wedding session at our studio, we noticed that our clients were interested in purchasing more than just 5 x 7- or 8 x 10-inch prints in their wedding albums. In fact, many began choosing infrared images for their wall print from their wedding day. We were routinely selling 11 x 14-, 16 x 20-, and even 20 x 24-inch wall prints from infrared. Most of the standard frame companies offered few if any framing options that would flatter black & white infrared wall décor. We were not satisfied with just using simple wood or metal moldings that did little more than hold the photograph, matt, and glass together and allow the print to be displayed on a wall. For this reason, we actively searched for a company

▶ **THE CLIENT IS NOT FORCED TO BUY THE FRAME, BUT WE WANT THEM TO VISUALIZE THEIR IMAGE IN A QUALITY FRAME.**

that could provide high-quality frames in alternative finishes. Our search has led us to Excel Picture Frames (Excelpictureframes.com). Excel is unique in that it offers a wide selection of wooden frames finished in black, gray, and pewter. These frames have a rich feel, provide a texture that you can't get from metal moldings, and above all, they look great with infrared images. Moreover, they are available in ready-made, standard sizes at a very reasonable cost. It was important that we did not have to have every frame custom-cut from moldings, and Excel's frames are assembled and ready to ship.

We understand that picture framing is a very competitive business, and customers have lots of choices from frame shops, department stores, discount stores, craft stores, gift shops, etc. to purchase frames. *We* stock many different styles and sizes of black, gray, and pewter frames at our studio. When a client returns to pick up their infrared wall image, we place the image into the frame we feel best complements the image. The client is not forced to buy the frame, but we want them to visualize their image in a quality frame. We point out that good frames for black & white images are hard to find. Most picture frames are stained in a popular wood shade—oak, maple, mahogany, cherry, etc. Most of the black frames commercially available to the consumer are very plain and ordinary with little decoration, style, or trim. Most of our clients purchase one of our Excel frames on the spot. Others go out and search for a frame on their own, only to call us back and buy one of our frames. Only with infrared and other black & white images is this true. I would love to tell you we have the same success with color wall print frame sales, but it just isn't the case. This is a great opportunity for every studio to add an additional sale to every client order.

CLOSING THOUGHTS

I have been very fortunate to learn so much about digital infrared photography through the photographs and writing of many talented image-makers. I want to take this opportunity to thank every photographer who contributed his or her images and ideas in the making of this book. Without their help and insight, this book would not be possible. I strongly encourage every reader to seek out infrared photographers around the globe. The World Wide Web provides each of us with the ability to access infrared images that we would never have seen a few short years ago. Do a web search for "infrared" and "digital infrared"—you'll be amazed at how much information is available if you just take the time to look for it!

I also extend special thanks to the technicians at Pro Camera & Video Service, who have modified my digital cameras as well as those for dozens of other photographers across the United States and Canada. Their expertise is beyond expectation. Digital infrared camera modification has made a world of difference in making digital infrared imaging a practical

▶ **I WANT TO THANK EVERY PHOTOGRAPHER WHO CONTRIBUTED HIS OR HER IMAGES AND IDEAS IN THE MAKING OF THIS BOOK.**

tool for the portrait and wedding photographer. I cannot overemphasize the importance of having a good relationship with a repair facility. You never know what can be done until you ask.

Last, I want to thank my wife, Barbara, for providing me the support and encouragement to see this project through to completion. The two of us run a very successful wedding and portrait photography business in Northern Ohio. Projects like this book would not be possible without her ability to run much of the day-to-day activity of the business.

INDEX

Also by Patrick Rice . . .

INFRARED WEDDING PHOTOGRAPHY

with Barbara Rice and Travis HIll

Step-by-step techniques for adding the dreamy look of black & white infrared to your wedding portraiture. Capture the unique, ethereal portraits your clients will love! $29.95 list, 8½x11, 128p, 60 b&w images, order no. 1681.

PROFESSIONAL DIGITAL IMAGING FOR WEDDING AND PORTRAIT PHOTOGRAPHERS

Build your business and enhance your creativity with practical strategies for making digital work for you. Covers all aspects of digital imaging. $29.95 list, 8½x11, 128p, 200 color photos, index, order no. 1780.

PROFESSIONAL PHOTOGRAPHER'S GUIDE TO
SUCCESS IN PRINT COMPETITION

Learn from PPA and WPPI judges how you can improve your print presentations and increase your competition scores. $29.95 list, 8½x11, 128p, 100 color photos, index, order no. 1754.

PROFESSIONAL TECHNIQUES FOR
BLACK & WHITE DIGITAL PHOTOGRAPHY

Digital makes it easier than ever to create black & white images. With these techniques, you'll learn to achieve dazzling results! $29.95 list, 8½x11, 128p, 100 color photos, index, order no. 1798.

WEDDING PHOTOGRAPHY
CREATIVE TECHNIQUES FOR LIGHTING, POSING, AND MARKETING, 3rd Ed.

Rick Ferro

Creative techniques for lighting and posing wedding portraits that will set your work apart from the competition. Covers every phase of wedding photography. $29.95 list, 8½x11, 128p, 125 color photos, index, order no. 1649.

CREATING WORLD-CLASS PHOTOGRAPHY

Ernst Wildi

Learn how any photographer can create technically flawless photos. Features techniques for eliminating technical flaws in all types of photos—from portraits to landscapes. Includes the Zone System, digital imaging, and much more. $29.95 list, 8½x11, 128p, 120 color photos, index, order no. 1718.

THE ART OF INFRARED PHOTOGRAPHY, 4th Ed.

Joseph Paduano

A practical guide to infrared photography. Tells what to expect and how to control results. Includes anticipating effects, color infrared, digital infrared, using filters, focusing, developing, printing, handcoloring, toning, and more! $29.95 list, 8½x11, 112p, 70 b&w photos, order no. 1052.

INFRARED PHOTOGRAPHY HANDBOOK

Laurie White

Covers black & white infrared photography: focus, lenses, film loading, film speed rating, batch testing, paper stocks, and filters. Black & white photos illustrate how IR film reacts. $29.95 list, 8½x11, 104p, 50 b&w photos, charts & diagrams, order no. 1419.

ADVANCED INFRARED PHOTOGRAPHY HANDBOOK

Laurie White Hayball

Building on the techniques covered in her *Infrared Photography Handbook*, Laurie White Hayball presents advanced techniques for harnessing the beauty of infrared light on film. $29.95 list, 8½x11, 128p, 100 b&w photos, order no. 1715.

TRADITIONAL PHOTOGRAPHIC EFFECTS WITH ADOBE® PHOTOSHOP®, 2nd Ed.

Michelle Perkins and Paul Grant

Use Photoshop to enhance your photos with handcoloring, vignettes, soft focus, and much more. Step-by-step instructions are included for each technique for easy learning. $29.95 list, 8½x11, 128p, 150 color images, order no. 1721.

THE ART OF COLOR INFRARED PHOTOGRAPHY

Steven H. Begleiter

Color infrared photography will open the doors to a new and exciting photographic world. This book shows readers how to previsualize the scene and get the results they want. $29.95 list, 8½x11, 128p, 80 color photos, order no. 1728.

BEGINNER'S GUIDE TO ADOBE® PHOTOSHOP®, 2nd Ed.

Michelle Perkins

Learn to effectively make your images look their best, create original artwork, or add unique effects to any image. Topics are presented in short, easy-to-digest sections that will boost confidence and ensure outstanding images. $29.95 list, 8½x11, 128p, 300 color images, order no. 1732.

PROFESSIONAL DIGITAL PHOTOGRAPHY

Dave Montizambert

From monitor calibration, to color balancing, to creating advanced artistic effects, this book provides those skilled in basic digital imaging with the techniques they need to take their photography to the next level. $29.95 list, 8½x11, 128p, 120 color photos, order no. 1739.

COLOR CORRECTION AND ENHANCEMENT WITH ADOBE® PHOTOSHOP®

Michelle Perkins

Master precision color correction and artistic color enhancement techniques for scanned and digital photos. $29.95 list, 8½x11, 128p, 300 color images, index, order no. 1776.

PLUG-INS FOR ADOBE® PHOTOSHOP®

A GUIDE FOR PHOTOGRAPHERS

Jack and Sue Drafahl

Supercharge your creativity and mastery over your photography with Photoshop and the tools outlined in this book. $29.95 list, 8½x11, 128p, 175 color photos, index, order no. 1781.

THE BEST OF DIGITAL WEDDING PHOTOGRAPHY

Bill Hurter

Explore the groundbreaking images and techniques that are shaping the future of wedding photography. Includes dazzling photos from over 35 top photographers. $29.95 list, 8½x11, 128p, 175 color photos, index, order no. 1793.

WEDDING AND PORTRAIT PHOTOGRAPHERS' LEGAL HANDBOOK

N. Phillips and C. Nudo, Esq.

Don't leave yourself exposed! Sample forms and practical discussions help you protect yourself and your business. $29.95 list, 8½x11, 128p, 25 sample forms, index, order no. 1796.

INFRARED LANDSCAPE PHOTOGRAPHY

Todd Damiano

Landscapes shot with infrared can become breathtaking and ghostly images. The author analyzes sixty of his compelling photographs to teach you the techniques you need to capture landscapes with infrared. $29.95 list, 8½x11, 120p, 60 b&w photos, index, order no. 1636.

PORTRAIT PHOTOGRAPHER'S HANDBOOK, 2nd Ed.

Bill Hurter

Bill Hurter has compiled a step-by-step guide to portraiture that easily leads the reader through all phases of portrait photography. This book will be an asset to experienced photographers and beginners alike. $29.95 list, 8½x11, 128p, 175 color photos, order no. 1708.